# Handmade
# Paper Collage

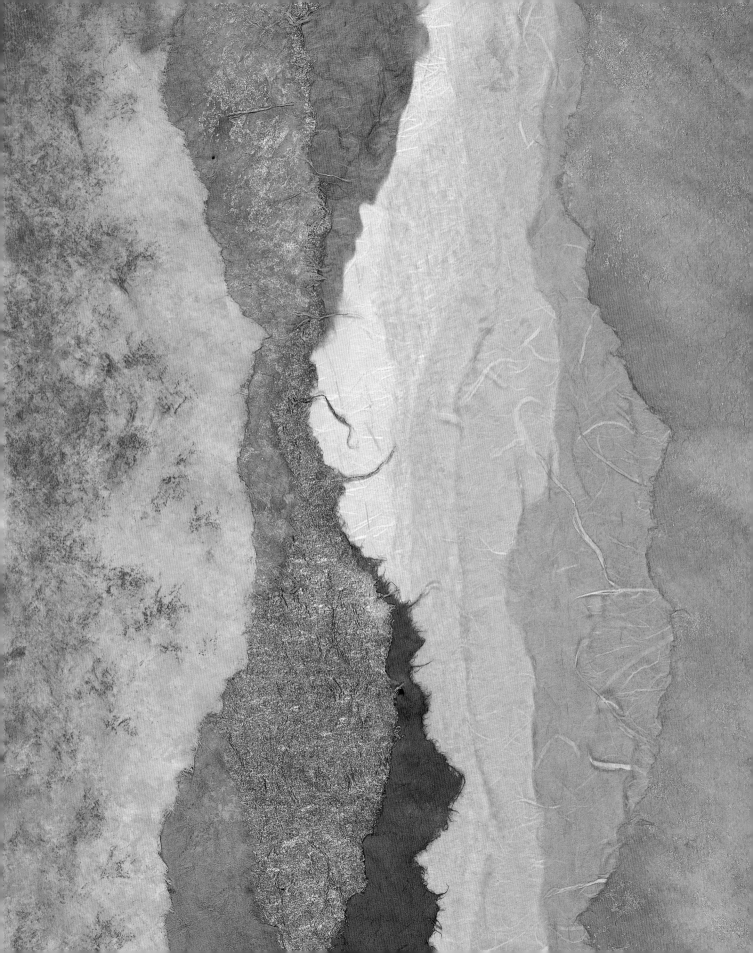

# Handmade
# Paper Collage

Dawn M. Ackerman

## Sterling Publishing Co., Inc.
### New York

## Prolific Impressions Production Staff:

**Editor in Chief:** Mickey Baskett
**Copy Editor:** Phyllis Mueller
**Graphics:** Lampe-Farley Communications
**Photography:** Jerry Mucklow, Martin L. Ackerman
**Administration:** Jim Baskett

Library of Congress Cataloging-in-Publication Data Available

10 9 8 7 6 5 4 3 2 1

Published by Sterling Publishing Company, Inc. 387 Park Avenue South, New York, N.Y. 10016

Produced by Prolific Impressions, Inc. 160 South Candler St., Decatur, GA 30030

©2002 by Prolific Impressions, Inc.

Distributed in Canada by Sterling Publishing c/o Canadian Manda Group, One Atlantic Avenue, Suite 105, Toronto, Ontario, Canada M6K 3E7
Distributed in Great Britain and Europe by Chrysalis Books
64 Brewery Road, London N7 9NT, England
Distributed in Australia by Capricorn Link (Australia) Pty. Lrd.
P.O. Box 704, Windsor, NSW 2756 Australia

Printed in China
Sterling ISBN 0-8069-6877-X

## Acknowledgements

As with any effort, there are many people who helped to bring this project to fruition. My thanks to my husband, who makes all things seem possible, and to my daughter, who inspires me each and every day. To my mother and sister, who listened and always offered encouragement. To my TNT group, who had to look at every piece that I made, thank you for putting up with it all. To Mickey Baskett for all her help pulling my work together into this book. And to the many teachers, mentors, and friends who offered their own work as inspiration, I hope that this book offers that same type of inspiration to others.

Special Thanks to the following manufacturers of products I used in this book:

*For water-slide decal paper:*
Lazertran Limited
8 Alban Square
Aberaeron, Ceredigion, UK SA46 OAD
Phone: +44 (0) 01545 571149    Fax: +44 (0) 01545 571187

*For rubber stamps:*
Fred B. Mullett Stamps from Nature Prints
Member - Nature Printing Society
P.O. Box 94502 Seattle, WA 98124 USA
Phone: 206-624-5723    Fax: 206-903-8202
Email: rbbrfish@compuserve.com    Website: www.fredbmullett.com

*For papers, embellishments, and adhesives:*
ArtPaper Inc.
Phone: 866-296-0404    Fax: 828-296-0505
Email: info@artpaper.com    Website: www.artpaper.com

US Artquest
7800 Ann Arbor Road
Grass Lake, MI 49240
Phone: 517-522-6225
Email: askanything@usartquest.com    Website: www.usartquest.com

Art Accents
4208 Meridian Ave
Bellingham, WA 98226
Phone: 877-733-8989
Email: diane@artaccents.net    Website: www.artaccents.net

# About the Artist
# Dawn Ackerman

Art, in one form or another, has been a constant throughout my life. I have enjoyed exploring and working with many different forms of artistic expression, most recently settling on collage as a primary focus. Collage is exciting to me because it allows me to create an image that I find as interesting up close as from a distance. The textures that can be achieved, both real and visual, through the use of handmade and handpainted papers inspire me. The addition of other elements, including crushed minerals, dried flowers, metal leafing, or beads, can provide further depth and interest. My collages are impressionistic and abstract. I do not attempt to recreate a specific image, as I might were I painting; instead, I "paint" with the paper to create an illusion of a landscape or to capture the emotion of a moment. (I have always, for example, loved the colors of the sky at sunset and sunrise, and use them often in my collages.) The papers I work with come from a variety of sources. Many are Japanese or Thai handmade papers, some are personally handmade, and others are as mundane as watercolor papers. I love to use all different weights and textures of paper, often enhancing the existing color of the paper with paint. I use watercolors, acrylics, inks, oil pastels, and dyes to change the color and visual texture that a paper has, thus creating a personal "palette" from which to create my images.

— *Dawn Ackerman*

*Dawn Ackerman, an artist for more than 20 years, holds degrees in Fine Arts and Business Computer Systems from New Mexico State University, Las Cruces, New Mexico. Her work is held in corporate and private collections and has been shown in galleries across the United States. Her collages also have been featured in both television and print media. Before devoting her full efforts to her art, she was a software engineer and engineering manager for more than 20 years. Born in Michigan, Dawn has lived in many states across the country and currently lives in Boise, Idaho, with her husband and daughter. Her work can also be viewed on her website: www.gallerydawn.com*

## Dedication

For Martin and Katie

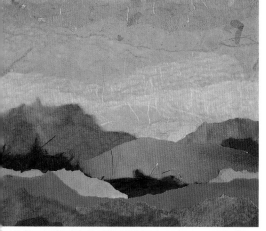
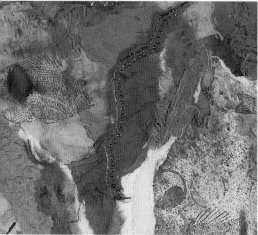
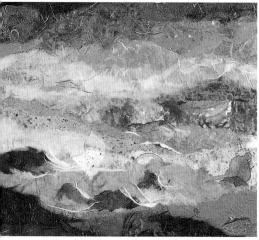
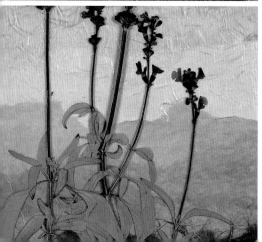

# Contents

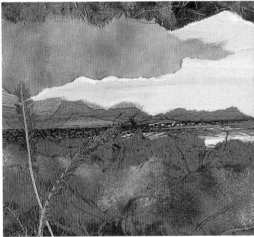

# Introduction

*"Every artist dips his brush in his own soul, and paints his own nature into his pictures."*

— Henry Ward Beecher

Quite simply, a collage is a work of art that has been created through the combination of relatively flat handmade or found materials by adhering these materials to a base or within a frame. Collage is a highly variable method of art, and there are as many styles as there are collage artists. Some works challenge us to see imaginary worlds filled with surreal images; others seem to be no more than a casual layering of paper intended to be pleasing to the eye. The images are composed of paper, string, and wire, and the range of artistic expression that can be demonstrated through collage is very, very broad.

Just as watercolor artists use paint colors, collage artists use paper as their palette. One important difference, though, is that collage artists use texture as an important element of their work. Today, there is a wonderful and beautiful array of handmade papers to be found in art and craft supply stores, rubber stamp shops, and even office supply stores. These handmade papers provide myriad colors and textures for creating images that are as interesting up close as they are from a distance.

The act of assembling components to make an image that is pleasing to you, the artist, is the foundation of collage. Most of us probably remember cutting pictures from magazines and shapes from construction paper and gluing the images to another sheet of construction paper—it is the first exposure that most of us have to collage. Kindergarten students today still love making collages—all they need

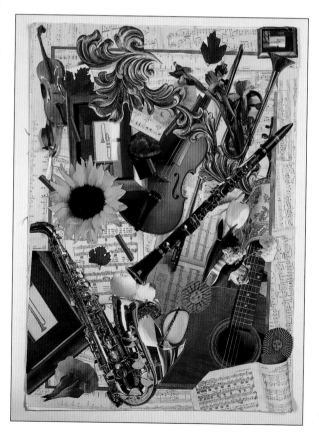

*Katie's Collage, age 5*

are collage elements (the pictures cut from magazines), glue, and a paper to glue the pictures on. They know that there are not many rules; they simply pick elements they like and glue them together. They sometimes choose a theme (such as music in this collage done by my 5-year-old daughter, Katie), or they use the cutout pictures to make their own scene. Children know that there is no "right" place for that piece of paper; the perfect arrangement is one they like.

This very lack of rules about what to use and how to create an image with collage elements is very liberating to some and very scary for many. Often those new to collage are afraid to tear up that beautiful piece of paper that they bought, but every one of us are already experienced collage artists. Like all other forms of art, it is important to have a sense of color, perspective, and composition. But collage doesn't have to be intimidating, and I hope that this book will help you to see collage as a fun and exciting art. (And maybe you'll even remember what fun you had in kindergarten!)

The projects in this book explore creating collage art primarily through the use of torn paper, with an emphasis on techniques I use for landscape collage. While it is clear from my work that my inspiration comes from nature, you—as the artist—will find your own inspiration, which will be reflected in the work you produce. Meanwhile, take the plunge and start tearing paper!

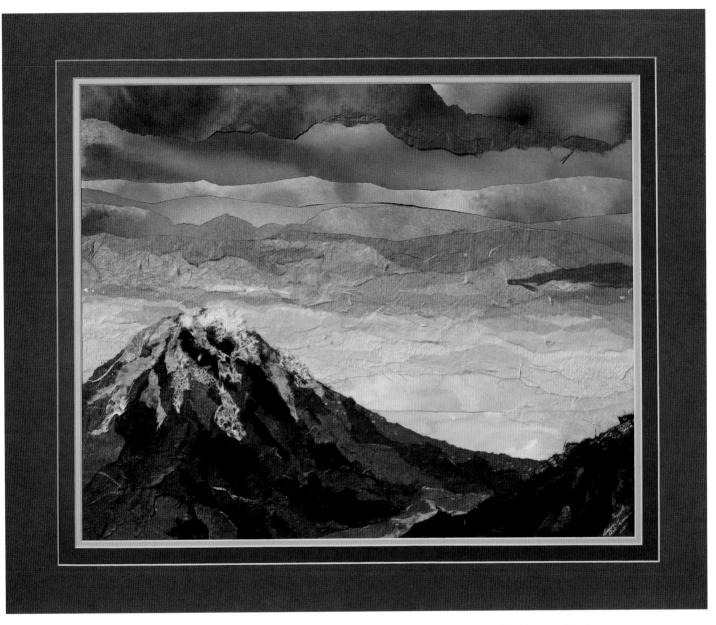

Within the pages of this book, I hope to offer you a blending of instruction and inspiration. I believe that artwork is a reflection of the artist and that it speaks of what is inside each of us. My wish is that you can take what I have learned through my own experiences and apply it to the process of creating a collage that reflects your own unique style and expression. Most of all, never forget that the act of creating a work of art can be fun and frustrating at the same time — that is all a natural part of the creative process. If I could impart but a single lesson, it would be to create in your own way. Learn from others but follow your own heart and creativity. After you have read through the instructions learned all the technical aspects of this art — go and tear up that paper you have been saving and make something even more personal and beautiful from it by incorporating it into your own artwork.

# Supplies for Collage

## Papers

The collage techniques in this book rely on the composition of interesting paper elements to create an image. The papers themselves, therefore, are critical elements to successful collage and the choices available are many and varied. It is important to have a variety of papers available—a paper palette composed of many colors, weights, and textures.

## Handmade Papers

Imported handmade papers are often made using traditional methods in India, Thailand, and Japan, where the history of papermaking stretches back 15 centuries. There are even papers made by Tibetan monks in Nepal. Really, these papers are works of art. Don't be afraid to try them. You will find you will like the feel and look of some papers better than others. Some of these papers are now reproduced using machines. (For the purposes of collage, the composition and look of the paper is important, not the papermaking process.)

### Tips for Choosing Handmade Papers

- I use lots of **sheer papers**. They are beautiful in and of themselves, and they help blend together colors through their translucence. Thai Unryu, Japanese Sanwa tissue papers, rice paper, and mulberry papers are some of the names you will see.

- **Lace papers** are often sheer—the holes and thin sections of the papers give them a lacy appearance. They are great for adding texture. Ogura lace paper is one of my favorites.

- Some papers with surface design or highlighting are wonderful when you **use the back** rather than the front.

- Some papers are great when **enhanced with painting or other coloring**. See "Making Your Own Handpainted Papers."

- Some handmade papers, particularly recycled papers, are **high in acid content**. Know when you use them that there is risk of discoloration over time.

## Watercolor Paper

Watercolor paper is a very strong paper with a high rag content that comes in a variety of weights and surface textures. For our purposes, watercolor paper is used for both the mounting board that holds the collage (called the **backboard**) and for creating handpainted papers. Watercolor paper can withstand large amounts of moisture without damage and is acid-free, making it a good choice for supporting large amounts of glue and paper.

**Hot press watercolor papers** have a smooth surface. **Cold press watercolor papers** have a slight visual texture. **Rough watercolor paper** is exactly what its name implies.

For the handpainted watercolor papers created in this book, 90-pound watercolor paper is used. It is lightweight and easy to tear, making it easy to integrate with other softer types of papers. I like to use all the various surface textures for painting.

For the collage base, 300-pound watercolor paper is my choice. It is heavy and can support multiple layers of papers. While any surface texture will work, I like the tooth of rough finish watercolor paper. It seems to grab the adhesive and the paper well.

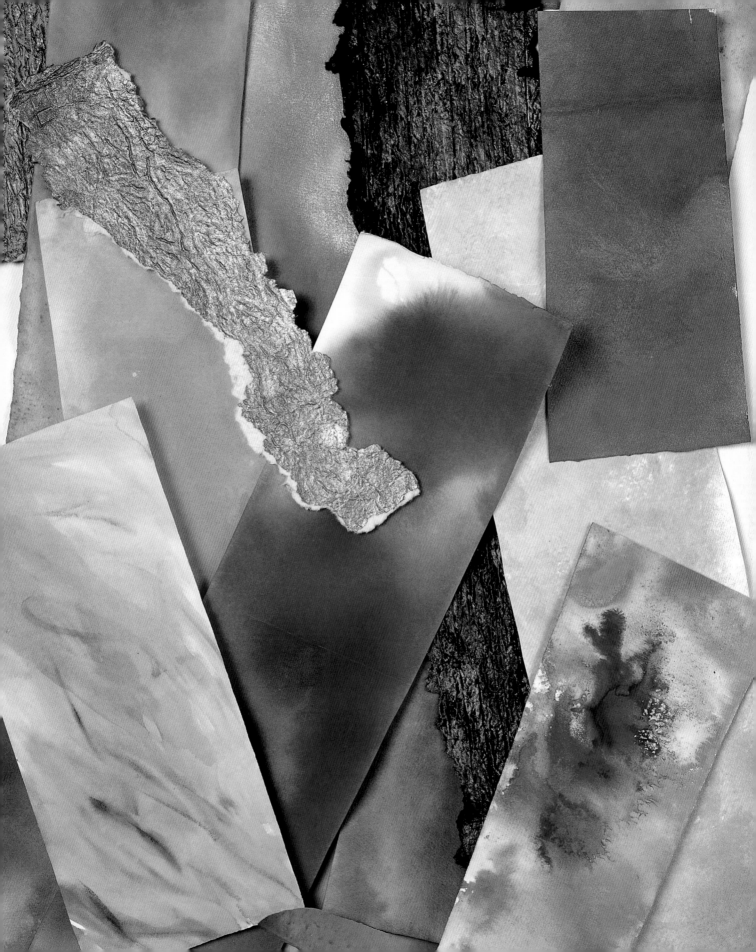

# Adhesives

I have experimented with many different types of glues in making my collages. There are glues made specifically for working with paper and paper collage; there are basic white glues, paste glues, acrylic mediums, and even rubber cement. Each product offers its own strengths—determining the adhesive that works best for an application is sometimes simply a personal choice.

The criteria that I have for my adhesive is that the product dries clear, remains flexible after drying, is acid-free, and can be cleaned up with water. There are many adhesives that meet these criteria. Following are my favorite adhesives.

## Polyvinyl Acetate

I recommend using a **polyvinyl acetate** (PVA) adhesive. It is a thicker adhesive that effectively holds heavy, stiff papers and very delicate soft, sheer papers without saturating them.

Polyvinyl acetate adhesive is often used in bookbinding because it is so flexible. Flexibility is important in collage because the many layers of paper and glue will sometimes curl the backboard as the collage dries. When you use a flexible glue, the backboard can simply be pressed flat without loosening the collage papers.

PVA is sold under several brand names and can typically be found in art supply stores, rubber stamping stores, or anywhere that sells bookbinding supplies.

## Acrylic Matte Gel Medium

**Acrylic matte medium** is another good choice for collaging. A **gel medium** works well for adhering heavier embellishments to the collage.

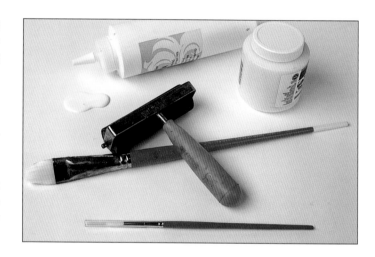

## Tools for Applying Adhesives

Using a **brush** to apply adhesives allows you to control the quantity and location of the glue. I like to use a 1" or 1-1/2" synthetic artist's acrylic brush. A brush that is somewhat firm gives better control, but a brush that's too stiff may disrupt the underlayers of the collage.

A **rubber brayer** is useful for pressing the collage paper to the backboard. Often **heavier** watercolor papers need this extra pressure to stay flat and adhere well.

# Cutting Tools

## Scissors

A sharp pair of **paper scissors** is necessary for trimming the edges of the finished collages—the scissors need to be sharp enough to cleanly cut through multiple layers of papers and the thick fibers in handmade papers.

## Other Cutting Tools

**Smaller paper scissors** and **decorative-edge scissors** are good to have for more detailed cutting. A **craft knife** is also useful. A **metal ruler** or **straight edge** can be used for tearing paper in a relatively straight line. A **deckle-edge ruler** has a rough, irregular edge that allows you to tear a relatively straight line with a rough edge.

# Embellishments

*"The important thing is not what the author, or any artist, had in mind to begin with but at what point he decided to stop."*

— D. W. Harding

Many times, the composition of papers alone creates an interesting collage. Other times, I have a sense that something else is needed. That's when I look at adding things to the collage other than handmade or handpainted papers. These items, which I call embellishments, may or may not be made of paper. They could be postage stamps or beads or dried flowers or thread, anything that adds interest and enhances the composition of the piece.

Sometimes, upon completion of an abstract collage, you may see representational images in the abstract design. Embellishments such as paints, threads, or crushed minerals can be used to further enhance that realistic impression, to emphasize a certain line or shape or to create new areas of interest for the overall image.

Keep in mind that many different kinds of embellishments can be used on the same collage. Here are some of my favorites:

## Mica Powders

These very, very fine pearlescent and metallic powders come in wonderful shades of gold, copper, red, and even blue, pink, purple, and multi-color iridescents. (You can mix them together to make unique colors.) Mixing mica powders with a binding agent, such as a thin adhesive or acrylic medium, makes a luminescent metallic "paint" for highlighting.

Use mica powders to lightly accent the edge of a torn piece of paper, or brush over a larger area to highlight it. Use them carefully—they catch the light and can overpower a collage if used to excess.

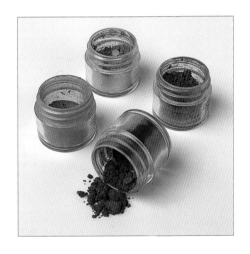

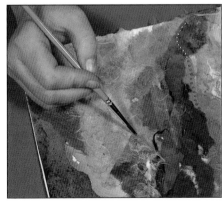

*Applying mica powder that has been mixed with an adhesive.*

### Here's How to Use Mica Powders:

1. Put a small puddle of thin adhesive on a paint palette or paper plate.

2. Pick up a small amount of mica powder on a small paint brush. Mix the mica powder with the glue, adding enough mica powder to create a pleasing color and look.

3. Using a small round paintbrush, apply the mica powder and glue mixture to the collage. Allow to dry thoroughly. If you have applied it on thickly, leave the collage flat to keep it from spreading or shifting.

## Crushed Minerals & Beads

Mica flakes and chips can be found in natural colors and subtle dyed shades. The inlay materials used for making jewelry or for woodworking are great sources of texture. Look in unexpected places for crushed stone materials, such as woodworking shops and rubber stamp stores.

Tiny beads—often found in rubber stamping shops—can add dimension to the surface of a collage. They come in many colors, both opaque and translucent.

### Here's How to Use Minerals:

*Use the same technique to add tiny glass beads.*

1. When your collage is completely dry, select a line or area to enhance—the edge of a torn piece of paper, perhaps, or a spot in the collage that needs a little extra something.

2. Using glue straight from the bottle, draw a line or design in glue or use a paint brush to apply it. The thickness of the adhesive will give different effects—thick glue will stand up on the collage; thin glue will lay flat and less minerals will be adhered.

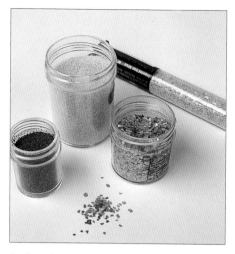

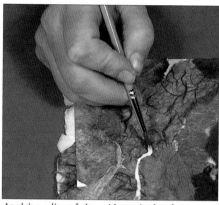

*Applying a line of glue with a paint brush.*

3. Sprinkle the crushed minerals on the wet glue. If the minerals include larger pieces, press them gently into the glue to ensure that they adhere securely.

4. Tap off the excess on a clean sheet of paper and return to the jar for later use. Allow to dry completely. Keep the collage flat or the glue may shift or move on the surface of the collage. Some excess minerals may temporarily stick to rough or lacy papers in the collage; they can be removed after the glue has dried.

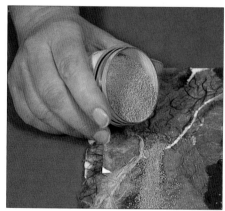

*Sprinkling crushed minerals from a jar over the wet glue.*

## Metal Leafing

Gold and other types of metal leafing can add a rich look when added as thin lines or to cover larger areas. Leafing material comes in sheets and packages of pieces. Smaller pieces are sold as a paper-making additive. Look for metal leafing at crafts and art supply stores. Follow the package instructions for application.

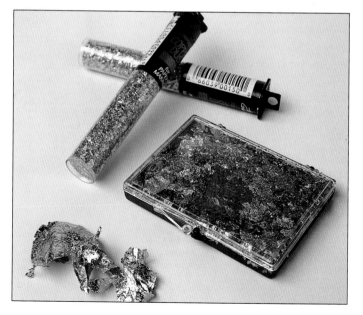

## Threads & Cords

Threads and cord come in a variety of thicknesses and textures. (Very thin threads will not show much.) Select a thread that goes well with the overall colors of the collage. Needlework shops are the best place to find threads—there are many types, including a variety of colored metallic threads (a favorite of mine). You also can find thread at many crafts stores. Threads and cords can be glued down in small pieces to add a fringed look or left long to meander through the collage.

### Here's How to Attach Threads & Cords:

1. Keeping the thread attached to its spool or cardboard, lay the thread against the collage, letting it loop and curve until it looks right to you. Cut the thread to fit.
2. Using a small round paint brush, apply a dot of adhesive to the collage at the starting point of the thread. Gently press the thread into the glue with your finger.
3. Continue to use this gluing method for the length of the thread, placing dots of glue only where necessary to maintain the line of the thread design. This allows the thread to be loose on the surface, so it adds a sense of dimension to the finished piece. Allow to dry thoroughly.

*Options:*
• Draw a thin line of adhesive on the collage and press the thread into the glue.
• To apply a small piece of thread, use a small dot of glue and press the middle of the piece of thread into the glue.
• To apply a series of small pieces of thread along a line, draw the line on the collage with glue, then press the middle of each piece of thread along the line of glue.

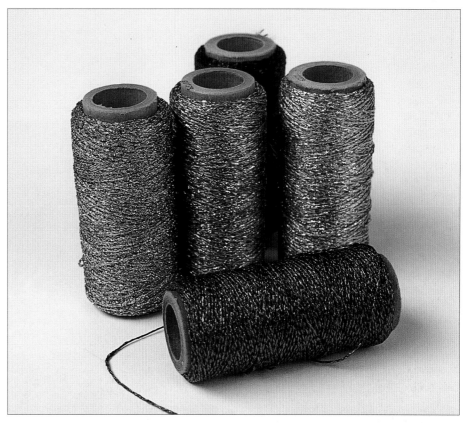

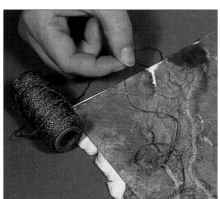

*Placing a metallic thread on a collage.*

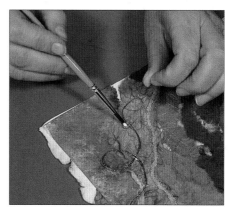

*Securing the thread with dots of glue applied with a paint brush.*

## Artist's Gels, Mediums & Pastes

These compounds, intended for mixing with paints and other types of artist's pigments, come in a variety of textures that can be interesting for adding finishing touches to collages. Use them with acrylic paints or oil pastels. One of my favorites is an iridescent, pearlescent tinting medium that turns any color of acrylic paint into a beautiful shimmery shade.

Apply gels, mediums, and pastes with brushes, palette knives, or rubber-tipped applicators for different effects.

## Dimensional Fabric Paints

Fabric paints come in a variety of colors and looks, including iridescent and sparkling finishes. They come in small dispenser bottles with built-in tips. Because fabric paints stay on the surface of the paper, they add a slight dimension to the design you create. Squiggles and lines of fabric paint dots can enhance a specific element of the collage. The hard finish of the raised design has an interesting look that's different from other embellishments.

You can use dimensional paints straight from the bottle. They will almost always adhere to paper. Because they may lift off a bit from soft-surface or lace papers, watch the paint as you lift away the paint bottle.

Dimensional paint can be used as an adhesive for mica chips or beads. If the beads or chips are translucent, the paint color will show through. Choose paint colors that work with the composition of your collage; my favorites are the iridescents.

### Here's How to Use Dimensional Paints:

1. With the paint bottle's applicator tip, draw a series of lines or designs.
2. While the paint is setting, before it is completely dry, press down any small points that may have been created when you lifted the paint bottle. Allow to dry completely before handling.

*Option:* For a high-shine effect, press a piece of cellophane on the paint. Allow to dry and lift off the cellophane.

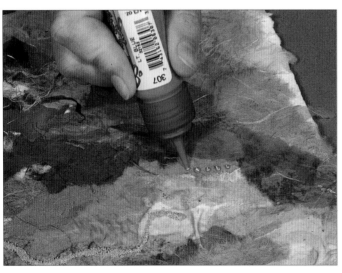

*Applying dots of dimensional fabric paint.*

## Rubber Stamps

Rubber stamps can be used to decorate papers prior to collage or can be used to add interest after the collage is complete. Specific images can be stamped directly on the collage, on collage papers, or on water-slide transfer papers. Designs and abstract images also add interest; one of my favorites is a crackle stamp.

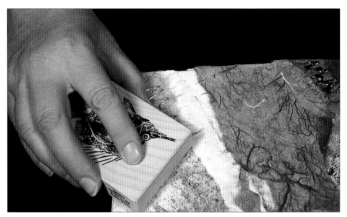

*Stamping on a finished collage.*

*The collage after stamping.*

## Stamping Tips

- Stamping directly on a collage can be a bit tricky. The surface is typically not smooth due to the layers of papers and different types of papers absorb ink differently.

- Always test your stamp on a sample piece of paper before attempting to stamp on your collage. Or stamp the paper before incorporating it into the collage.

- Choose the stamps carefully. Dye inks, in particular, can bleed into the paper and blur the image. For some images, this will not matter and may even be desirable; for others, the rubber stamp image would be lost.

## Embossing Inks

Embossing is done by stamping an image with embossing ink, adding embossing powder, and melting the powder with a heat gun or embossing tool. Embossing inks do not tend to blur into papers as dye inks do, but try a sample first. Embossing designs on a collage must be done carefully; if you have used heavily fibered papers in your collage, be sure all the tiny loose fibers are glued down—they can easily ignite under the intense heat of an embossing tool.

## Other Embellishments

- To add a touch of realism to your abstract or landscape collage, try **postage stamps**. Their detailed images can enhance the theme of a collage, and there are thousands of choices from all over the world. Add a wildflower stamp to the corner of a mountain landscape, coordinating both the image and the colors or add a tropical fish stamp to an abstract collage in blues and greens.
- **Pressed leaves and flowers** add foreground interest in a collage. A single fern leaf can become a tree, or the collage could become a background for displaying the beauty of a single flower or autumn leaf.
- **Old photographs** added to your collage adds a personal touch to your art.
- Small **seashells or slices of seashells** can be adhered to a seashore collage.
- Glossy **tiles**, either purchased or created with rubber stamps and layers of embossing, can be interesting.
- Incorporate **old keys, coins, fabric scraps**, or pieces of **window screen**. Look around your house, experiment, and be creative!

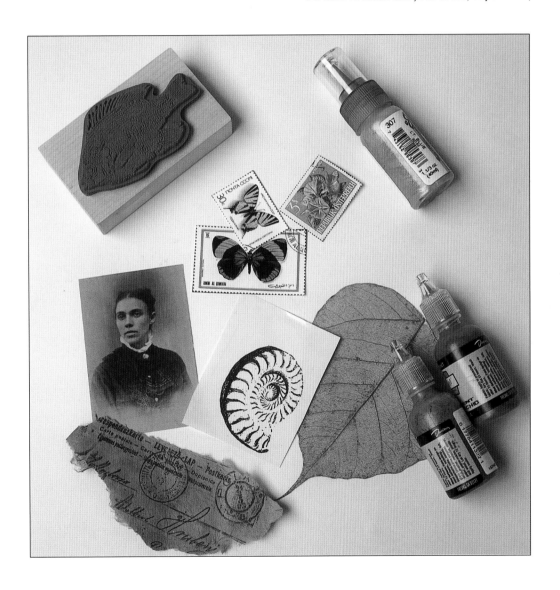

# Making Handpainted Papers

*"Colour is my day-long obsession, joy and torment."*
— Claude Monet

The papers that a collage artist uses must provide a myriad of interesting colors and textures, and there are many different types and looks of papers available for purchase. However, I found myself constrained by the colors available or the lack of visual texture that I wanted. Some of my early collages were composed of drawings and paintings I had done that did not work as individual pieces of art. Using them led me to the idea of painting paper specifically for a collage, and I found the handpainted papers I made much more satisfying than using magazine images. Handpainted or hand-colored papers vastly expand the colors and visual interest in your paper palette, enabling a collage to go from mildly interesting to stunning.

## Choosing Products

When coloring papers, be sure to use good quality supplies. It would be beyond disappointing to create a beautiful work of art, only to find that the papers have faded or discolored. I had an unfortunate experience with a new type of paint—I assumed it to be light-fast, but found instead that it faded even in low light over a couple of months and discolored dramatically in full sun.

It's best to use caution and test products you are unsure of. You can test paints simply and easily by painting a small scrap of watercolor paper with the paint and placing it in typical lighting conditions for several months, then comparing it to a newly painted piece of paper. To test in sunlight, I paint a strip of paper about 6" long and fold it in half, allowing half the paper to be exposed to strong light while the other half remains face down. Because of the delicate nature of paper, I would not expose finished artwork to harsh lighting, but I like to know that the coloring agents I use would withstand any reasonable conditions.

I am often asked if I intentionally paint elements of a scene when I am painting papers. The answer is yes and no. I do think about the colors that might be interesting in a sky or mountain or ocean when I'm selecting colors, but I also like to introduce colors that are unexpected. Remember the papers you paint are not finished artwork, but are intended to be torn up for your collage (although sometimes the pieces themselves are beautiful).

I find the more collages I do, the more color I like to use and the less constrained I feel about using realistic colors. I don't try to re-create a specific image, but instead I try to evoke emotions and my personal impressions of images I have seen or imagined. (I find unusually colored elements can really breathe life into a collage.)

## Watercolor Paints

Watercolors are transparent colors that allow the underlying color of the papers to show through the paint. I use artist's watercolors, which come in tubes, as well as liquid concentrate watercolors. These liquid watercolors are high intensity pigments that are the consistency of water and come in small bottles with eyedropper lids. Select colors that appeal to you as well as colors that will work well in elements of a landscape, e.g., blues and purples for skies.

## Acrylic Paints

Acrylic paints come in many colors and finishes. Unlike watercolors, they are opaque and provide heavy coverage. I am particularly attracted to an iridescent or metallic finish in these paints, which can be attained through using purchased metallic or iridescent paints or through the addition of iridescent tinting medium to regular paint. Acrylic mediums are mixed with paint to create different looks or textures. Acrylics that come in a liquid form in plastic squeeze bottles work well on watercolor paper.

## Oil Pastels

A small set of artist's oil pastels provides an easy way to highlight the surface of rough-finish handmade papers. Oil pastels are soft

"crayons" that color very easily and can be layered to blend their colors. They are water soluble and provide opaque color.

## Paint Brushes & Applicators

- For creating color washes, a **large watercolor brush**, either round or flat, works well.

- **Fan brushes** can be used to introduce streaks of color.

- For stippling layers of acrylic paints, **foliage brushes** and **stippling brushes** are terrific to have on hand. They work on watercolor papers as well as heavier handmade papers.

- A **small round brush** can be dipped in water and used to outline a shape on many handmade papers, enabling you to tear them along the wet line.

- A **stippling tool**, found in art and craft stores, is nice to have for spattering, but an old toothbrush works just as well.

- **Natural sea sponges**, with their rough textures and irregular edges, are used to apply watercolors and acrylic paints and to remove excess paint and water from overly wet papers.

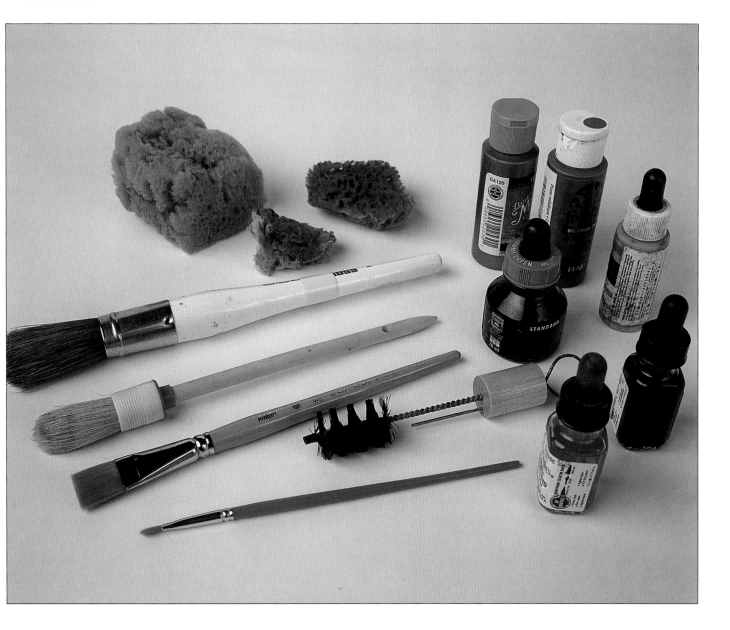

# Dropper Method on Wet Paper

This fun technique is unpredictable and always yields very interesting papers. You can use concentrated watercolors, liquid acrylics, airbrush acrylics, or calligraphy inks. Don't be afraid to combine types of paints. I freely mix translucent watercolors with opaque acrylics. Experiment!

Use color combinations that work with the types of collages that you want to make. For example, I like to put purples, blues, and magentas together for stormy skies.

## Supplies

90 pound watercolor paper
Paints
Eyedropper
Sea sponge
Spray bottle
Paper towels
Water container
*Optional:* Rubber gloves

## Preparation

Cover your work surface with plastic. Select your paint colors. Assemble your supplies at your work area—once you start, you will need to work quickly.

## Here's How

1. Thoroughly wet a strip of 90 pound watercolor paper using a faucet or by spritzing the surface of the paper. You want a lot of water on the surface of the paper to allow the paint to move across the paper freely. Dry spots on the paper may not get colored when moving the paints, and dropping color directly on dry paper can result in very quick absorption of the paint (and spots of color that won't blend in).

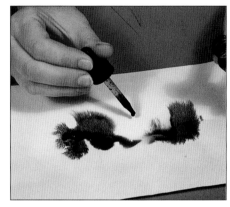

2. Using the eyedropper dispenser, drop paint on the wet surface of the paper. Put multiple drops of paint around the surface.

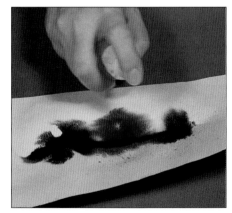

3. Spritz water on the paper as needed to keep the paper very wet. Drop the second and subsequent colors on the paper. Do not cover the entire surface—the paints will spread widely across the paper and cover the open areas.

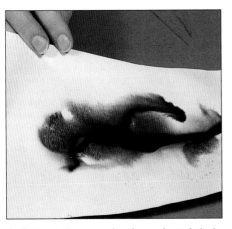

4. Pick up the paper by the ends and tip it, allowing the paints to move on the surface and blend.

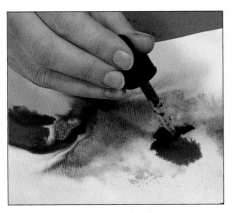

5. Add more paint with the dropper.

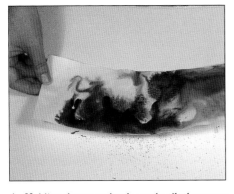

6. Holding the paper by the ends, tilt the paper to spread the paints, allowing them to mingle on the surface. When the paints are blended to your satisfaction, touch a dry paper towel to the edge of the paper to drain away some of the excess paint and water.

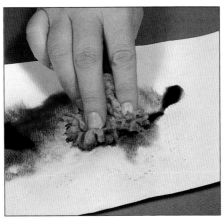

7. Use a sea sponge to lift any remaining excess paint and water from the surface. Fill any spots of white paper with the paint on the sea sponge. The sponge will leave impressions on the surface of the paper that add visual texture.

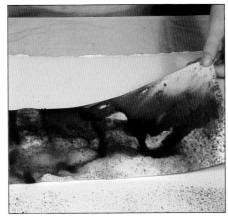

8. If you want lighter speckles on the paper, spritz the paper with water. You can also create lighter impressions on the surface by pressing with a clean, wet sea sponge. If the paint is not moving freely or if there are dry spots, spritz the paper. Spritzing the paper with the paints on it will spatter paint across the paper, adding interest. Allow the paper to air dry. It is likely to ripple, but that's okay. (You can flatten it later.) ❧

## Hints & Tips

- The paint will stain your skin, so you may want to wear rubber gloves.

- If your sea sponge has a very regular or smooth edge, tear the edges to make the impressions more interesting.

- Covering your work surface with a large piece of 90 pound watercolor paper and leaving it in place while painting multiple papers can result in a beautiful (and unpredictable) paper that you can use in a collage. (And you won't waste excess paints from the other papers you've created.)

- If you are using only watercolors, you can sprinkle salt on the wet painted surface. The salt will absorb some of the water and paint, leaving a frosted look.

- Cover the surface with plastic food wrap and let it dry for another interesting look.

# Sponging with Paint

Using a sponge to apply paint creates an interesting textured look. Use multiple sizes and textures of sponges and different textures of papers to achieve different effects.

## Supplies

90 lb. watercolor paper or heavy handmade paper
Paints, such as acrylic paints and/or artist's watercolors (in tubes)
Sea sponges
Paint palette

## Here's How

1. Prepare your work surface by covering it with plastic and putting a sheet of scrap paper on top. Squeeze watercolor paints into the cups of a paint palette and mix with a little water to make the paints creamy. If you are using acrylics, do not mix with water.
2. Cut or tear a strip of paper for painting. (The torn edges of handmade papers absorb paint nicely, so I prefer to tear them.) For a more controlled tear, use a small paint brush to paint a line of water. Allow the paper to absorb the water, and the paper will tear easily along the wet line.
3. Wet a sea sponge and squeeze out excess water. Dip the sponge into one color of paint and press the sponge to the surface of the paper, transferring the paint.
4. Clean the sponge and pick up the next color, continuing in the same fashion until the paper is covered. Overlap paints to blend the colors to your satisfaction. Notice that acrylic paints are opaque and the paper cannot be seen through them, but the paper is visible through watercolors.
5. Add highlights if desired by sponging acrylics over top of painted paper, whether painted with watercolors or acrylics. Allow the paper to dry thoroughly. ∾

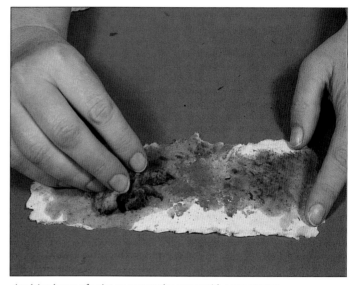

*Applying layers of paint on watercolor paper with a sea sponge.*

## Hints & Tips

- Be sure to squeeze excess water from the sponge when sponging on handmade papers—they tear easily along wet lines and can fall apart if they get too wet. To remove more water, try wrapping the sponge in dry paper towels and squeezing to remove more water.

- If the paper gets too wet, let it dry. Then go back and continue to apply color.

- If a handmade paper becomes saturated with paint and water, do not move it while wet—it will tear. Let it dry on your work surface.

# Watercolor Washes

Use watercolors to create transparent effects on paper.

## Supplies

Watercolor paints
Brushes: Large round and flat watercolor
    brushes, fan brush
90 lb. watercolor paper
Paint palette
Water container

## Here's How

1. Select your paints and load the paint palette. Mix paints with a little water to thin them. Have a container of water readily available.
2. Using a thoroughly wet brush, dip brush in paint and brush over the surface of the watercolor paper.
3. Moving quickly and cleaning the brush

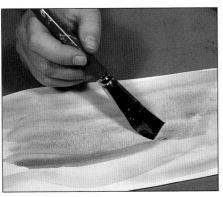

*Using a flat brush to apply a watercolor wash.*

between colors, continue to add color to the surface of the paper, overlaying paints to blend colors.
4. Add highlights to the paper using a fan

brush loaded with thicker watercolor pigments, if desired. Allow the paper to dry. The paper may ripple, but that will not impact its use in the collage. ❧

### Hints & Tips

- Don't just wash the paints in a straight line across the paper; instead, make curved lines for interesting results.
- Remember watercolors are translucent, so the underlying color will show through.
- Washing sections of the paper and blending them yields a more interesting effect.

# Stippling with Paint

Stippling uses a brush to apply paint to paper that results in a textured look. You can pick up multiple colors of paint on the stippling brush—this is an effective way to blend colors.

## Supplies

Acrylic paints
Stippling and foliage brushes
Paint palette
90 pound watercolor or handmade paper

## Here's How

1. Lift a small amount of paint with the bottom bristles of the brush. Work the paint into the brush by pushing the brush down onto a scrap paper
2. Tap the paint onto the surface of the papers, noting that the color will gradually lighten. Stipple the paint until little or no color is coming off the brush.

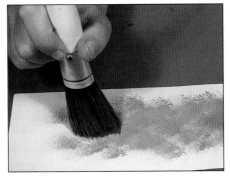

*Stippling with a brush to create a textured look.*

3. Pick up the next color, without washing the brush, and continue stippling color on the paper. Overlap colors, very lightly, to blend colors. ❧

### Hints & Tips

- Highlight with white or light colors after the other colors are dry for interesting effects. You can do this with stippling or by sponging color with a sea sponge.
- Allowing the underlying paper color to peek through the stippling will give a more textured look to the finished paper.
- Because you are using opaque acrylics, if you are dissatisfied with the look of the painted paper, let it dry. You can apply more paint to cover your first efforts.

# Highlighting Papers with Paint

You can use a sea sponge or a spattering tool to add painted highlights to papers—the idea is that the paint partially covers the paper, enhancing and/or creating a texture. For contrast, try dark-colored paints on light papers or metallic paints on dark papers.

## Supplies

Rough-finish handmade papers
Acrylic paints
Sea sponge
Spattering tool or old toothbrush
Paper towels

## Here's How

**Highlighting Rough-Textured Papers:**

1. With a damp sea sponge, pick up a small amount of acrylic paint. Blot sponge on a scrap of paper or a paper towel to remove excess paint.
2. Gently wipe across the surface of the paper, using a light touch. The high areas of the textured paper will be painted; the lower areas will retain their original color.
3. Add more color, varying the amounts of paint for a mottled look, still allowing the original paper color to show through.

*Option:* For a very light highlight, use a paper towel wrapped around your finger to apply small amounts of paint to high surfaces.

*continued on page 26*

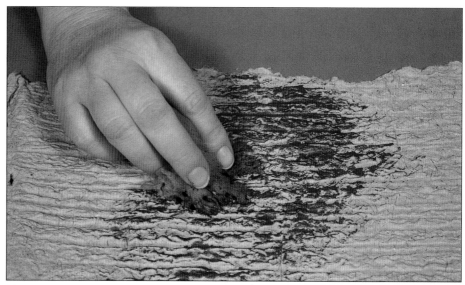

*Using a sponge to apply dark-colored highlights to the surface of a rough-textured paper.*

## Hints & Tips

- If you have problems controlling the amount of paint transferred to the paper, you have too much paint in the sponge. Wash the sponge and re-load with less paint.
- If you don't have a spattering tool, use an old toothbrush. Run your thumb over the bristles to generate the spatters.
- You can use spattering to highlight previously handpainted papers.

*"Know what the old masters did. Know how they composed their pictures, but do not fall into the conventions they established. These conventions were right for them, and they are wonderful. They made their language. You make yours. All the past can help you."*

— Robert Henri

**Highlighting Smooth Surfaces or Delicate Papers:**

1. On a paint palette, thin the paint to a watery consistency.

2. Pick up paint on the spattering tool, making sure not to pick up too much paint. The amount of paint on the brush determines the size of the spatters. Less paint makes smaller spatters. Remove excess paint with a paper towel, if needed.

3. Holding the spattering tool over the paper, run the stick part of the tool over the bristles, spattering paint on the surface of the paper.

4. Repeat the spattering, using subsequent colors. If you spatter wet on wet, the colors will tend to blend. To avoid blending, allow the paper to dry between spatterings. Let dry completely before using in a collage. ❧

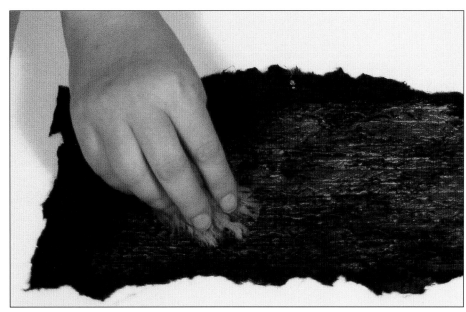

*Using a sponge to apply highlights to a dark-colored, rough-textured paper.*

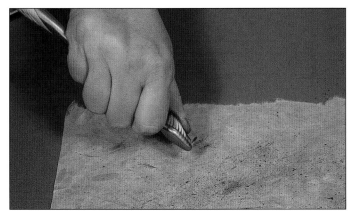

*Spattering mulberry paper with an old toothbrush.*

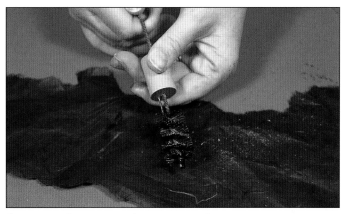

*Spattering mulberry paper with a spattering tool.*

## Other Paper Decorating Ideas

• **Use rubber stamps and dye inks** to add abstract or specific images to handmade and handpainted papers. If using handpainted papers, make sure the papers are thoroughly dry before stamping, and be aware that handmade papers absorb ink differently—some will soak up the ink and/or blur detailed images.

• Make your own recycled paper! (There are books available to guide you, or take a class.)

• **Use paper towels to transfer the look of the texture.** Simply lay a paper towel on the surface of wet watercolor-painted paper. Try other textured absorbent items as well.

• **Airbrushing** works well on delicate papers and gives a soft look.

• **Make your own spray paint.** Mix paints with water to the consistency of thinned ink. Put in a spray bottle and spritz color on paper.

• **Combine painting techniques** to create your own style.

• **Experiment!** Papers that don't look terrific on their own can look great when torn into small pieces.

# Collage Basics

*Test knowledge through experience, be prepared to make mistakes, and be persistent about it."*

—Leonardo da Vinci

All the projects in this book were created using the simple techniques in this section. The techniques are the culmination of my experience but are certainly not the only way to do collage. I encourage you to find a method that works well for you, gleaning insight and information from what is offered here. Remember there really is no right or wrong way to create a collage—there is only a way that works for you.

## Tearing Paper

This may seem like a silly topic, but it is important. You may not notice how the edges of a piece of paper look when you are tearing up your junk mail. The look of the edges, however, becomes very important when you are doing torn paper collage.

### Handmade Papers

In handmade papers, the fibers swirl throughout the sheet, rather than laying in a specific direction. When you tear handmade papers, you can feel the long fibers pulling apart, leaving beautiful "hairy" edges. Most handmade papers tear (actually, they pull apart) very easily when wet, making it possible to control the shape or line being torn. Use a wet paint brush to paint a line, allow the paper to absorb the water, and gently pull the edges apart.

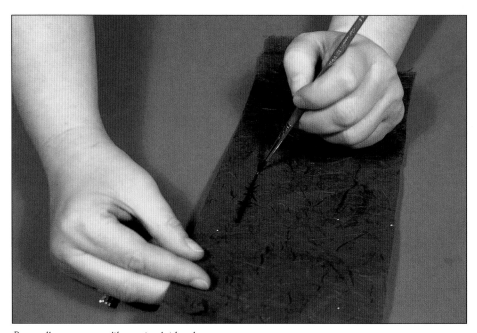

*Draw a line on paper with a wet paint brush.*

### Surface-Painted Papers

Whether these are watercolor papers that you have painted yourself or machine-made printed papers you have purchased, when the color or design is only on a single side of the paper, there will be two distinct types of torn edges. One side of the tear will show a narrow white edge; the other side will have the surface design all the way to the edge. Lay the paper flat on a table, colored side up. Taking one side, lift it to tear the paper. Notice that the piece that remains on the table has the white edge.

Since the upper part of the tear retains the surface design, you can manipulate the tear to get a look you like. Sometimes I like a white edge of a piece of paper. Other times I tear back and forth to get an irregular white edge, and often I tear the edge so no white shows.

You can also create a highlighted edge by painting the white edge with a similar or complementary color. Use the technique that works for your collage.

### Tearing Straight Lines

Every once in a while, you will want a straight edge on a torn piece of paper. To do this, use a ruler or other straight edge. Place

the paper on your work surface and position the ruler on the paper along the line you want to tear. Lift the edge of the paper and, holding the ruler firmly on the paper, tear the paper up and along the edge of the ruler. This technique retains the look of a torn edge, but the line is relatively straight. Using a deckle-edge ruler produces a straight line with a rough edge.

Papers with heavy fibers are difficult to tear in a straight line. The fibers swirling through the paper may not tear—they may pull out of the piece as you tear, leaving interesting threads protruding from the straight edge or they may stop the tear completely. If that happens, use scissors to cut the specific fiber that is impeding your progress. Or use the water technique: Using a straight edge as a guide, load a paint brush with water and paint a straight line on the paper. Tear the paper along the line after the water has been absorbed.

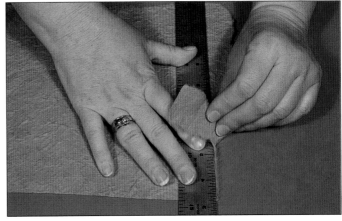

*Place ruler on the paper along the line you want to tear.*

*Gently pull the paper apart.*

*Lift the edge of the paper to tear.*

*Tearing using a deckle edge ruler.*

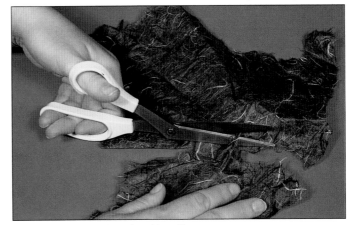

*Using scissors to cut through stubborn fibers.*

## Applying Adhesives

It is important to control the amount of adhesive when putting your collage together. To ensure that I have good control of the glue I'm applying, I use a firm synthetic bristle brush to apply adhesive.

For best results, apply glue very lightly to lightweight papers and more heavily to heavier or thicker papers, such as handpainted watercolors. I find that I get the better results on most papers by applying the glue to the backboard rather than the piece of paper itself. The exception is handpainted watercolor paper. Watercolor paper is made to withstand water saturation, so it withstands the wetness of glue. Because handpainted papers often ripple as they dry and because they are heavy (compared to most handmade papers I use), I apply adhesive to the back of them. Use a brayer to ensure that the watercolor paper is firmly pressed against the backboard.

Too much glue can saturate papers, making delicate, sheer papers transparent and making handmade papers tear very, very easily. It is difficult to judge the strength of a handmade paper just by looking at it; some thick papers are very fragile when wet (with water or adhesive), and many will leave fibers from the papers on your glue brush. One of my favorite

attributes of handmade papers is the longer fibers that swirl throughout the page. Because I like the look of these edges (I call them hairy), for most flat collages, I do not glue down the edges. Instead, I leave them loose, clearly showing the layers. If you want those edges tightly glued down, ensure that adhesive covers the entire area, then apply adhesive on the top of the edges (in essence, painting them down with glue).

## Underpainting

Some artists prefer to design their collage prior to applying the paper and may choose to do an underpainting that delineates key areas. Underpainting is simply the process of painting the design on the backboard with watercolor or acrylic paints. The painted areas guide the placement of color and line as the collage is developed and help keep the overall desired composition visible during the collage process. This technique can be seen in the "Peony" project

While I tend to follow a more fluid process and design the collage with the paper, I do use a version of this concept. Using paper, instead of paint, for example, I lay out a large mountain of dark gray in a landscape. This enables me to continue to work the sky and the foreground while reserving the area where the large mountain will be. Later, I go back and add detail to this large area. Essentially, I use paper to create an underpainting. (We explore this technique in the project "Snow on the Mountain.")

## General Hints & Tips

- I use the backboard to guide the size of the finished collage, so the first step is to cut 300 lb. watercolor paper to the chosen size. Mark the paper and cut it with heavy scissors or a sharp craft knife.

- While the size of the backboard will be the finished size of the collage, I don't keep the paper inside the boundaries of the backboard as I work, but rather let the papers fall off the edges. It's good to keep sharp scissors handy for trimming the edges.

- Have a scrap sheet of paper handy when applying loose embellishments, such as mica powder. Since the fine material will be poured on wet adhesive, tapping off the excess on a piece of paper makes it easier to pour the powder back in a container.

- Allow your handpainted papers to dry thoroughly before collaging. I typically spend several hours just painting papers. When I'm ready to make a collage, I don't stop to paint papers in the midst of collaging.

- As I work, I find I often need to view the collage from a distance. After I put together a collage, I prop it up and look at it from across the room, sometimes for several days, before completing the piece. I may do this several times when working on a very detailed or a very large composition.

- When selecting papers for your collage, do not get attached to a specific piece of paper. Often a particular paper inspires me to start, but it may not end up in the final piece or it may be completely covered up. That paper served its purpose (inspiring me), even though it may not be visible in the collage I made. I have watched people struggle and fuss because they don't want to remove a piece of paper they really liked when they started—by doing this, they are limiting themselves by insisting the paper remain in the piece.

# Adding Realistic Images to a Collage

*"Every production of an artist should be the expression of an adventure of his soul."*

— W. Somerset Maugham

Realistic images can enhance the interest in a collage. Realistic images can come from magazines, photographs, or rubber stamping—magazine pictures are the traditional source. Images can be worked into abstract collages or placed on top of a collage, making the collage a background for the images. Always respect copyright laws regarding the use of published images and respect the work of other artists.

## Magazines

Be aware that most magazines are not printed on acid-free paper. Using an adhesive or acrylic medium to coat the paper will slow its discoloration.

## Photos

Because photos have a shiny surface finish, I rarely use them in my collages. If I want a photographic image, I make a color photocopy. Another option is to copy the image on water-slide transfer material. (More about this below.)

## Rubber Stamps

Rubber stamping, either directly on the collage or on paper to be included in a collage, is another interesting option for including images.

## Wallpaper

Another source of images is wallpaper. Wallpaper stores often give away old sample books—these are interesting to explore. Ornate borders or specific motifs can be cut out from the overall images.

## Water-slide decal transfer paper

This very interesting, versatile medium allows you to transfer images to surfaces that otherwise would be difficult, if not impossible, to transfer images to. You photocopy the image on the transfer paper, cut it out as desired, then submerge it, and remove the paper backing, leaving a thin, clear, non-adhesive image that can be glued to any surface. The decal has a sheen that is visible on the collage, but the edges can easily be covered and integrated into the collage so that this is not a distraction.

I like using this paper to place images on collaged papers that are not smooth enough for direct application of images. It also works well because it handles color images. Use this for photographs and other colored pictures for interesting effects on colored papers. This paper also lets you place stamped images on papers that are unsuitable for any ink application, where the inks may bleed and blur the image. Follow the manufacturer's instructions for use.

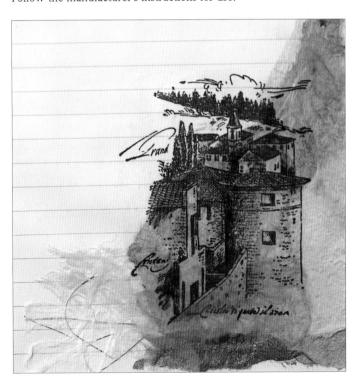

# Composition & Perspective

*"A man paints with his brains and not with his hands."*

— Michelangelo

Collage artists, like painters and sculptors, must have a sense of perspective and a feel for composition. This means paying attention to the placement of each paper in relation to the other pieces as well as to the boundaries (edges) of the collage.

Considerations include looking at each color you add to see if it is too bright or too dull relative to the other colors in the collage as a whole as well as to adjacent colors. Developing a sense of composition and understanding perspective are skills that are developed with practice. For my style of collage, there are no hard and fast rules, but there are guidelines that help make collages more interesting.

## Create a Focal Point

Any collage should have a specific area—a focal point—that draws your attention to it. This can be a prominent line, a particular area of color, or an image in the work. Lack of a focal point can make a collage look flat and uninteresting.

In a landscape collage, the focal point is often the horizon line, particularly if the collage portrays a colorful sunrise or sunset. The contrast of colors between the sky and the foreground inherently catch the attention of the viewer. In an abstract collage, line, color, and contrast can be used to create a focal point. Sometimes a surprising color will draw the eye, or the white torn edge of a paper will create an interesting line. Other times, it is the overall sense of movement captured in the collective placement of papers that creates a flow in the work.

You will know you need to keep working on a piece if it does not sustain your interest when you look at it. Use more paper or other embellishments to create or strengthen the focal point in your collage. I don't stop when I've placed enough paper to cover the backboard; instead, I add more papers, colors, and lines until I am pleased with the overall effect.

## Place a Dividing Line

Whether you are creating a landscape collage or an abstract collage with specific segmentation, it is important to pay close attention to the line which divides the piece. In a landscape, this is the horizon line, which divides the sky and the ground. Placing the **horizon line** across the middle, equally dividing the collage space, is the least interesting place for it—it visually divides the work and can make the collage look like two separate collages glued together. Move the line up or down a little (or a lot!) for a more pleasing effect. Moving it down places more emphasis on the sky; moving it up focuses the viewer's attention on the ground.

While abstract collages do not have a horizon line, they can have lines that divide the work, and the same principles apply. Equally dividing the work with color or line is usually much less interesting than a subtle shift off-center. This is also true for the focal point of your collage, particularly if it contains a realistic image. Placing it directly in the center might well look a bit like a bull's eye on a dartboard—probably not the effect you want. Shift it a bit—you'll be surprised at how much more interesting the composition becomes.

## Perspective

Perspective is shown in realistic artwork by placing those things that are farthest from the viewer so they appear to recede. In landscape collage, this means that the sky must appear to be behind the ground, as it would if you were looking out your window. So the meadow in front of the mountains must look as though it is lower and sitting at the base of the mountain range, rather than sitting on top of the mountains.

Color and the amount of detail can be used to achieve good perspective in your work. The foreground typically has more detail than the background, so (extending the previous example), a meadow at the base of a mountain range would have more detail (the addition of blooming flowers, perhaps) than the mountains beyond it. (Flowers high on a mountain would not be visible from the other side of the meadow..)

Use nature as your guide or deliberately choose to alter and manipulate the natural perspective of things to create surreal impressions.

# Matting & Framing Your Collage

Nothing finishes off a beautiful collage like fine matting and framing. Just as putting the collage itself together takes time and patience, choosing mats and frames also takes time—but it is time well spent. Consider the matting and frame as the mechanism for presenting your collage to yourself and others as it hangs on the wall. It will make a difference.

## Considerations

There are very few rules about matting and framing collages. Sometimes you want to contain the collage you've created; other times you want to extend the colors outward. I consider mats and frames an extension of the collage image. Here are some considerations:
- Because papers cannot be cleaned, your collages should be framed behind glass. I use a very thin, museum quality glass so that the colors of the papers are not muted by the greenish color of glass.
- The collage should not press directly against the glass—this will flatten the image, causing it to lose some of the interest created by the varying textures of the papers and the shadows created by loose edges.
- To protect the papers, do not hang a collage pieces in direct sunlight, no matter how it is framed.

## Choosing Mats

Because I love to see the colors of a collage enhanced by matting, I take time to select complementary mats for my collages. I (almost always) triple mat my work, leaving a scant 1/4" of mat showing next to the collage itself, moving outward with another mat where 1/4" to 1/2" is visible, and finishing with a wide outside mat, 2" to 6", depending on the size of the collage. (Triple matting also gives enough space between the glass and the collage to keep the papers from being pressed against the glass.) I choose colors for mats from the finished collage that enhance, but don't overpower, the overall look of the collage. One guideline is to use brighter colors for the mats closer to the collage and a more subdued color for the wider mat.

## Choosing Frames

Select a frame that is compatible with the collage and with the space where you want to hang it. I prefer a narrow metal frame, either in a color that coordinates the overall collage and mat combination, or in gold, silver, or black. If your collage includes highly dimensional objects, you may wish to consider a shadow box frame to accommodate the depth of the piece. Shadow box frames come in varying depths and include spacers that keep the glass away from the collage.

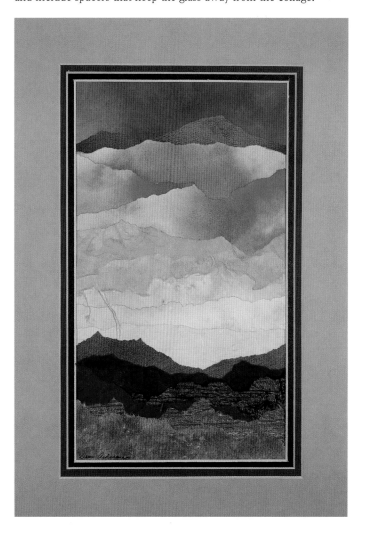

# Landscape Collage

*"I look out the window sometimes to seek the*
*color of the shadows and the different greens in the trees, but when*
*I get ready to paint I just close my eyes and imagine a scene."*

— Grandma Moses

To ME, NOTHING IS AS BEAUTIFUL AS NATURE. It inspires me and lifts my spirits to see the vivid colors of a sunset sky or the delicate colors at dawn. The purples, greens, and rich browns of the distant mountains, the coppers, rusts and golds of the desert, these are my inspiration. To capture the image of huge white clouds drifting across a blue sky, mixing with grays and purples and a touch of pink or the colors of the land beneath a dark and stormy sky is a challenge that is irresistible. Landscape collage is a method for capturing the essence of what we see around us through creating images with torn papers. The lines found in nature, coupled with a strong sense of color, allow you to create illusory landscapes that capture the feel of what we see.

The landscape collages I create are not an attempt to capture a specific image, but are, instead, a composite of all that I see everyday. Look carefully around you and you will indeed see that a tree is not just green, but many shades of greens. What colors are visible in the sky when the sun is just below the horizon? It is this eye toward the colors that you see that will breathe life into your landscapes. Next, look at the lines that are created in a mountain range. Are they rolling hills, with softly curving shapes, or are they sharp rugged lines, with deep shadows etched into them? Can you see the repeating lines of the waves on the ocean and the gentle curves of the sand dunes? How does the contrast of light and shadow draw lines into a canyon? Once you begin looking at nature with this eye toward seeing the lines and colors, you will begin to pull together your own internal vision of nature. Using papers to capture these lines and colors is the essence of landscape collage. It is my hope that these projects will get you started by teaching you the techniques that I use, and that you will carry this knowledge forward and be inspired to express your own vision of nature.

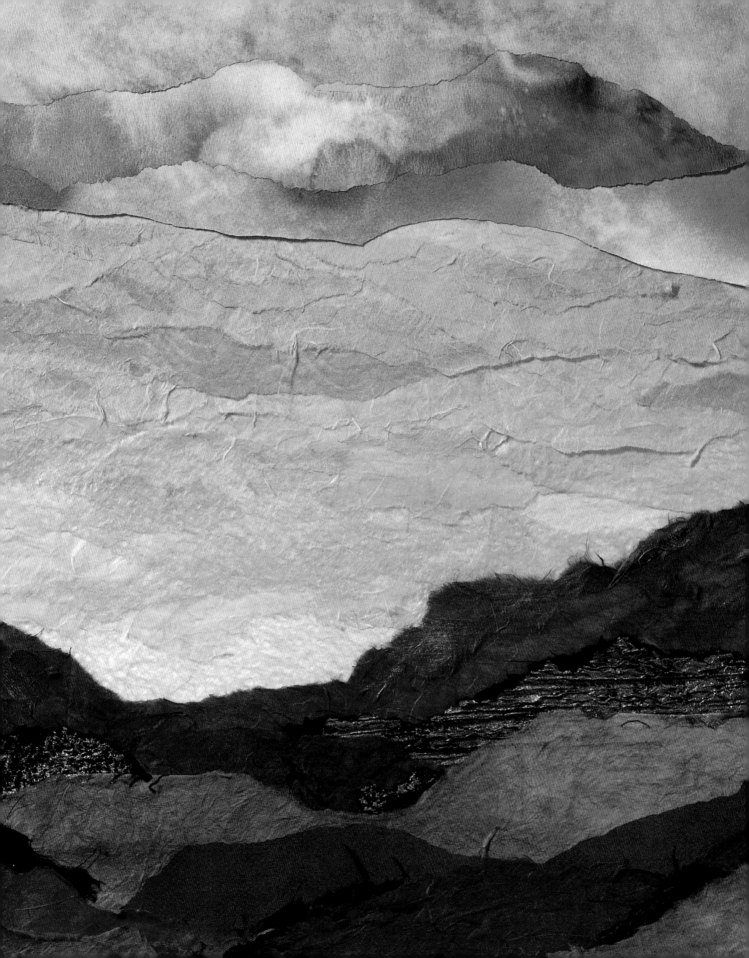

# Landscape Project
# Step-by-Step Technique

*"There are painters who transform the sun into a
yellow spot, but there are others who, thanks to their art
and intelligence, transform a yellow spot into the sun."*

— Pablo Picasso

This project demonstrates the basic technique I use on all my landscape collages. The landscape is designed as you go, rather than drawn on the backboard, and no papers are glued until the collage design is complete. For inspiration, look at the land around you or at books of photographs to get a sense of color and line in nature. The landscapes you produce will reflect what you see. For this project, I used warm desert colors and vivid sunset sky shades. Gather many more papers than you think you will need, since it is impossible to predict what papers will work best prior to the actual creation of the collage. I like to make sure that the papers have a variety of textures and tones. You want to have some papers that are brighter and darker than others; rich darks and vivid shades are critical for adding interest to the collage.

## Supplies

Assorted handpainted and handmade papers
300 pound watercolor paper, 7.5" x 12.5", for the backboard
Polyvinyl acetate adhesive or acrylic matte medium/gel
1" paint brush, for applying adhesive
Rubber brayer
Scissors

## Here's How

1. **Prepare.** Cover your work surface with paper or plastic. Assemble your supplies and an assortment of papers which represent the type of landscape that you want to create.

2. **Select the paper for the horizon line.** This will be the lowest sky color in the landscape. This piece of paper will be beneath the subsequent layers of the sky and the ground; it is the only paper that will have both edges flat to the backboard. Lay the paper in place; do not glue. Don't worry about the width of the paper—let it fall over the edges of the backboard.

3. **Build the sky.** Begin shading the sky from the color at the horizon line up to the top of the backboard. My collage is starting with a

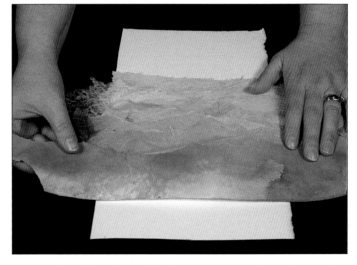

pale yellow. From there, I shade up through peaches, pinks, purples, and blues to create the stormy skies I see in the handpainted papers I made. Overlap the papers and vary the amount of paper that shows. Some papers may only show for one-quarter of an inch; others may have 2" or 3" showing. The top of the sky is one of my favorite places for handpainted papers. Remember, nothing is glued yet; the papers are sitting on the backboard.

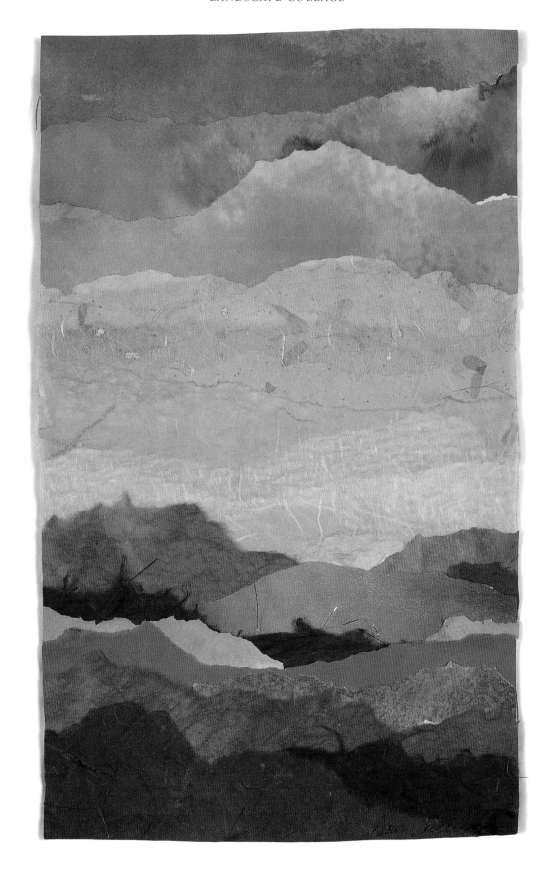

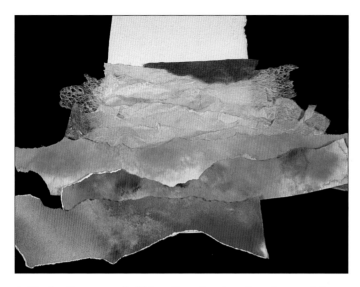

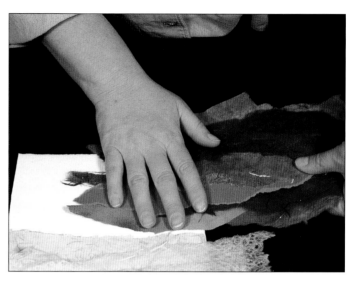

4. **Begin the ground.** This collage is a layering of rugged desert mountains. Starting with the farthest mountain, the one closest to the sky, tear and layer the back mountain, overlapping into the sky papers. It may only overlap a single paper or it may overlap a dozen papers, depending on the details of the sky and the angles of the mountain.

6. **Move the mountains.** Once the entire backboard is covered and the collage has been composed by the layers of paper, it is time to glue the collage. This part always makes people nervous because they are afraid they will lose their composition. (Don't worry, it always goes back together better than ever.) Leaving the horizon paper and sky in place, slide the mountain papers off the backboard.

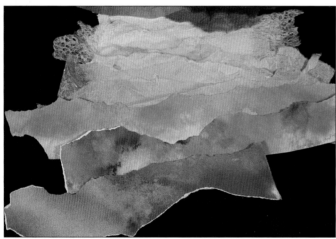

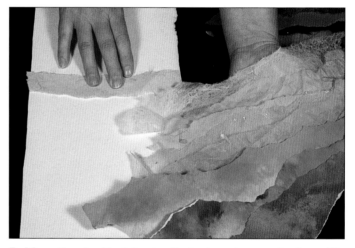

5. **Build toward the foreground,** layering papers in the same fashion as the sky. While the collage technique is the same as for the sky, the composition is different. You are not trying to shade the mountains. Rely instead on the interest created by the color and texture of the paper to give dimension to the mountains. The mountains should show wider layers of papers (between 1" and 4"). Vary the colors and tones of the papers to balance the vivid sky. Again, you are just laying out the papers, not gluing them down.

7. **Move the sky.** Next, leaving the horizon sky paper in place, slide the sky papers off the backboard.

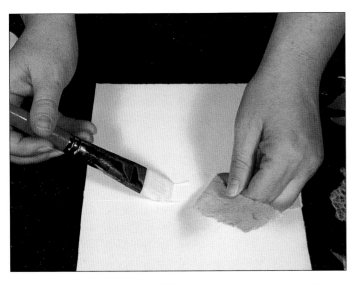

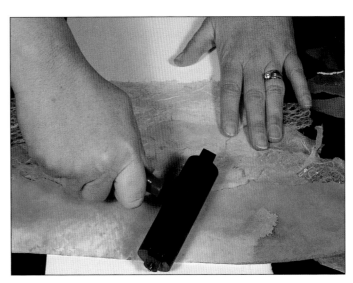

8. **Glue the horizon paper.** Glue in the same order as the layout, beginning with the horizon line of the sky. Since both edges of this paper will be covered with layers, glue it flat to the backboard. Use the brayer, if necessary, to keep it flat.

9. **Glue the sky.** Apply glue to the backboard (and on the horizon line paper, if needed). Add the next sky paper to the collage. Use a very light hand with the adhesive, particularly if you have used lightweight papers for the sky. Leave the edges loose for added interest.

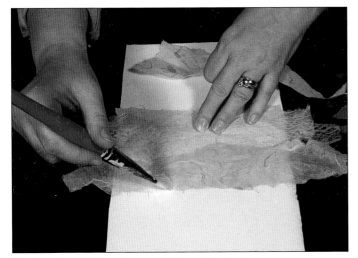

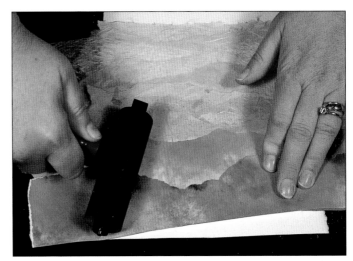

8. *(continued)* **Glue the remainder** of the horizon.

9. *(continued)* **Assemble the remainder of the sky,** following your composition. Use a brayer to flatten heavier papers.

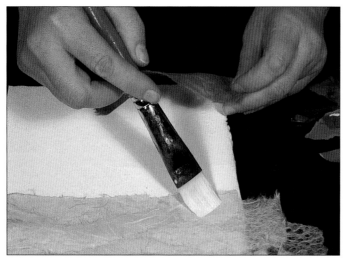

10. **Glue the mountain.** To get a sense of where to place the glue, lay the farthest mountain on top of the now-glued sky. Holding the paper in place, lift one side of the paper and apply adhesive to the backboard. Lift the other side to complete the gluing. This technique ensures the glue is where it belongs.

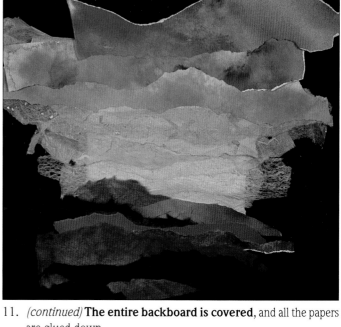

11. *(continued)* **The entire backboard is covered**, and all the papers are glued down.

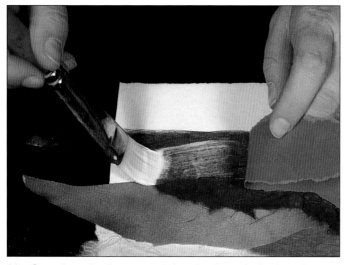

11. **Complete the foreground,** layering from the horizon down to the bottom of the backboard.

12. **Turn over the collage and trim the excess paper** along the edges of the backboard. This is an exciting part because trimming the edges defines the edge of your collage, and it becomes a finished piece.

## Hints & Tips

- Save the trimmed edges to use in other projects. No piece of paper is too small for collage!
- The two-step process of first layering the papers, then gluing them, is really an editing process. Spend time on each part.

- Don't be afraid to subtly change the composition as you glue. Tearing a piece of paper to change the line it creates or shifting the layers a bit might create more interest.

*This is an outline drawn for the collage that shows layering of the papers. Notice the different widths of paper strips and the changing angles of the overlapping layers.*

*Enlarge to 135% for actual size*

# Snow on the Mountain

*"To the dull mind nature is leaden. To the illumined mind the whole world burns and sparkles with light"*

— Ralph Waldo Emerson

What is more striking than the vision of a mountain, snow still capping its peaks, shadows darkening its crevices? The rugged edges of the mountain meet the sky and create a dramatic line. This collage project explores adding layers of papers to the surface of an image to add detail to large areas in the landscape. Include in your palette a selection of black and dark gray papers and sheer and lace papers in whites.

## Supplies

Assorted handpainted and handmade papers
300 pound watercolor paper, 10" x 13", for the backboard
Polyvinyl acetate adhesive or acrylic matte medium/gel
1" paint brush, for applying adhesive
Rubber brayer
Ruler or straight edge
Scissors

## Here's How

1. **Prepare.** Cover your work surface with paper or plastic and assemble your supplies. Assemble an assortment of papers to create a vivid sky, along with blacks, grays, and whites for the mountains. Add very dark blues, browns, and purples for the shadows of the mountain.

2. **Lay out the sky.** Using the basic layering technique, begin at the horizon line and lay out a preliminary sky for the collage. This is preliminary—you may re-work the sky after laying in the dark mountains.

3. **Create the mountain silhouette.** With the sky layered, tear a large silhouette of the mountains from medium to dark gray paper. You may create the entire mountain range with a single paper or use several pieces of papers. The silhouette of the mountain should extend to the bottom of the backboard.

4. **Re-evaluate the sky** to see that it contrasts well with the silhouetted mountains. You may need to increase the vividness of the sky colors or to shift the colors to work with the line of mountains since they extend over many levels of sky papers.

5. **Glue.** Glue the sky, following the techniques described earlier in the book. Glue down the mountain silhouette. Trim the edges of the collage along the backboard using sharp scissors.

6. **Add snow.** Tear small pieces of white papers and begin laying snow on the mountain peaks. Use opaque papers for key areas and to establish hard edges. Use sheer papers for a softer look; lace papers will lend a mottled look that is very effective. Do not glue these papers yet.

7. **Add shadows.** Working with black or very dark-colored papers, tear and lay in shadows on the side of the mountain. Use the papers to create interesting lines, giving a rugged quality and adding depth to the large gray mountain that is glued down. Use lighter gray as needed to add interest to the sides of the mountain.

8. **Keep manipulating** the combination of the whites and blacks or darks until you are satisfied with the look of the mountain. Glue each piece to the collage.

9. **Step back and study.** Place the collage across the room and study the mountain from a distance. Continue to add dark and light colored papers to the collage until you are satisfied that the collage is complete.

## Hints & Tips

- Look to see where is the most vivid section of the sky. Move the papers to ensure it is visible. Sometimes the silhouette can cover the most interesting part of the sky. Since the mountain extends up into the sky, papers can be shifted so they are covered by the edges of the mountain without extending completely across the backboard.

- If your collage has a vividly colored sunset or sunrise sky, adding sheer papers in pinks and oranges to the snow areas will give the scene more realism since snow typically reflects sky colors. Mute the pink and orange papers by overlaying with sheer whites if their tones are too bright. Study landscape photo-graphs to see what this looks like.

- You can modify the line created by the mountain silhouette by adding small pieces of papers to the edge. Rough lines are far more interesting and realistic-looking than smoothly torn edges.

- If desired, add a few specks of mica flakes for highlights in the mountains. Place these one flake at a time, rather than filling an entire section—you want the flakes to reflect a little light, not overpower the scene.

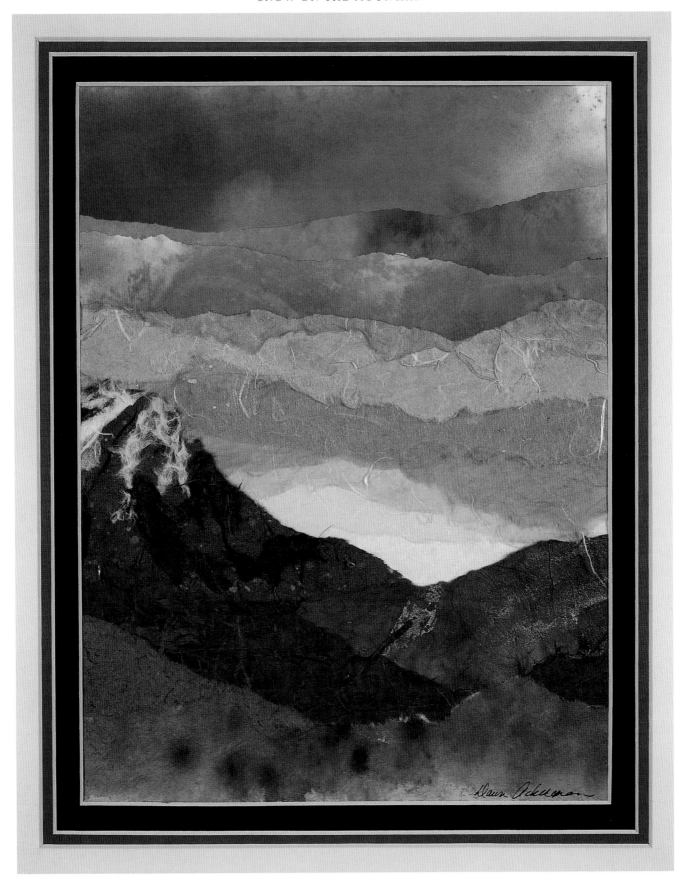

# Ocean Vigil

*"Painting from nature is not copying the object;*
*it is realizing one's sensations."*

— Paul Cezanne

Imagine sitting on the beach in the tropics. A soft breeze is blowing and the sky is still streaked with the colors of the sunrise. This project evokes those images and feelings. The basic composition is a simple layering technique. Details are added by layering smaller torn papers over the top of the basic landscape. For this project, I used aquas and blues for the ocean, whites and soft blues for the sky, and creams and tans for the sand dunes. Be sure to include a selection of sheer and lace papers in whites and soft pastel pinks, blues, and lavenders. Narrow strips of paper, layered closely together, create the illusion of waves.

## Supplies

Assorted handpainted and handmade papers
300 pound watercolor paper, 10" x 17", for the backboard
Polyvinyl acetate adhesive or acrylic matte medium/gel
1" paint brush, for applying adhesive
Rubber brayer
Ruler or straight edge
Scissors

## Here's How

1. **Prepare.** Cover your work surface with paper or plastic and assemble your supplies. Assemble an assortment of papers that represent the landscape you want to create.

2. **Place the horizon line and the sky.** Beginning with a white or light cream paper, lay the horizon line paper just over halfway down the backboard. Layer strips of papers up to the top of the backboard, creating the sky for the landscape. You are not gluing anything yet—you're composing the sky.

3. **Tear the darkest ocean paper.** Using a ruler or straight edge, tear a relatively straight edge on the darkest of your ocean colors. This paper meets the sky at the horizon.

4. **Layer the ocean.** Shading the papers to achieve an ocean look, layer the papers down toward the bottom of the backboard. Shade the ocean with the darkest color near the horizon line to add depth.

Because you will be adding foreground interest with the seashore, these papers do not need to extend completely across the backboard.

5. **Create the sand dunes** on the shore by tearing segments of papers, more triangular-shaped than strips. Place them on the backboard, inserting them between layers of ocean where you want to see the shore. Re-arrange your ocean papers as necessary.

6. **Glue the horizon.** Slide the papers off the backboard, leaving the horizon paper in place. Glue this paper to the backboard.

7. **Glue the sky and ocean.** Beginning at the horizon, glue all sky papers to the backboard. Then glue the ocean and the shore, working the sand dune papers into the composition as you go.

8. **Trim.** When all papers have been glued, trim the edges of the collage with scissors.

9. **Add finishing touches.** To create the impression of the last colors of dawn, take very small strips of pastel pink and lavender sheer or lace papers and lay them on the sky. (You want to pull down blues into the white areas and whites into the blues—pinks and lavenders mix in with those colors.) The pieces are between 1/4" and 1/2" wide and typically 2" to 4" long—you do not want large pieces.

10. **Glue and finish.** When you have arranged the overlaid strips in the sky, glue them using very little adhesive, leaving the edges loose. Trim any pieces that extend beyond the backboard. Allow to dry. ❧

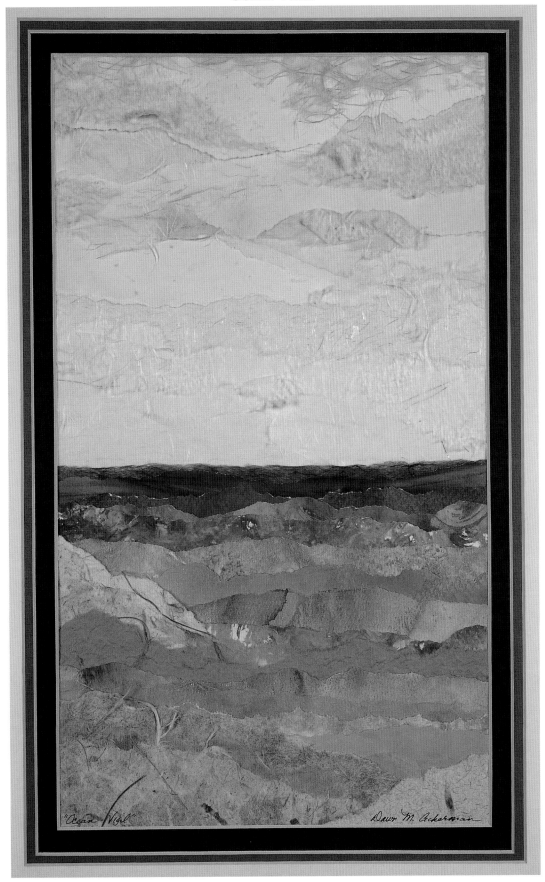

# Falls at Yosemite

*"I try to apply colors like words that shape poems,
like notes that shape music."*

— Joan Miro

My inspiration for this collage came from seeing Yosemite Falls. Using vertically layered papers, this collage demonstrates how layering papers creates the impression of the striations in the rock formation of the cliff. Heavy handpainted papers work well in this collage if they have directional texture.

Try to keep the layers of the rock face simple. The vertical impression of this collage is gained from the vertical lines created by the edges of the paper—you do not want to blur this impression. The texture of the paper makes the wall look rough and can add to the impression of rock striation.

Use a sheer unryu paper with long metallic threads for the waterfall to introduce sparkle.

## Supplies

Assorted handpainted and handmade papers
300 pound watercolor paper, 7.5" x 12.5",
    for the backboard
Polyvinyl acetate adhesive or acrylic matte
    medium/gel
1" paint brush, for applying adhesive
Mica flakes
Rubber brayer
Scissors

## Here's How

1. **Prepare.** Cover your work surface with paper or plastic and assemble the supplies. Assemble an assortment of brown, copper, and black papers to create the rough rock wall. Select an interesting handpainted paper for the sky and a lightweight, sheer white for the waterfall.
2. **Place the sky.** Lay the selected sky paper across the top of the backboard. This segment of the collage is small and is easily done using a single strip of paper. I prefer a handpainted paper for this, to include variation in the coloring.
3. **Begin layering strips of paper vertically** on the backboard. At this point, do not worry about the line created by the edges of the papers, even if they completely cover the sky. You want the strips of papers to create the vertical striations found in rock, and you want the colors to blend. Use texture to enhance this rough, rocky surface.
4. **Create the top edge of the cliff.** Lay a straight edge at a slight diagonal across the top edges of the papers. Tear each piece of paper along the straight edge to create the top edge of the cliff. (You can do this by gradually sliding the papers down; you want this edge to be fairly clean, even, and on the diagonal.) This diagonal line gives the illusion of perspective.
5. **Glue and trim.** Glue all papers to the backboard once you have completed the layout. Trim the edges of the collage along the backboard.
6. **Create the waterfall.** Tear a strip of sheer white paper several inches wide. Loosely twist the paper to create a narrow strip, allowing the paper to have a slight variation in width.
7. **Place the waterfall.** Select the point where the waterfall flows over the top edge of the rock face. Holding one edge of the twisted paper in place, shape the waterfall to flow down the rock face. Use the "give" in the twisted paper to pull it into the shape you want. Glue in place. Trim excess from the edge.
8. **Embellish.** Add small pieces of sheer whites as needed to enhance the look of the waterfall. Add a few flecks of shiny mica as random reflections in the water. ❧

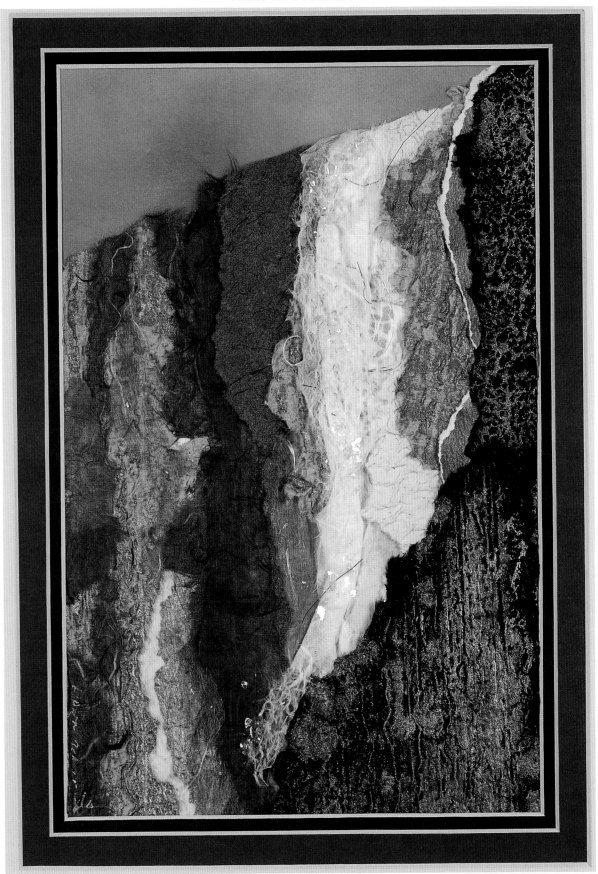

# In the Canyon

*"I found I could say things with color and shapes that I couldn't say any other way—things I had no words for."*

— Georgia O'Keeffe

This project uses papers, layered both vertically and horizontally, to create the image of a canyon and waterfall. It is a complex image. Many layers of paper are used to create the illusion of shadows in the water. The depth of the image draws the viewer into the scene.

For this project, I used heavily textured browns, rusts, and coppers for the canyon, a vivid blue for the sky, and grays, blues, and whites for the river. You need sheer papers for the waterfall and river.

## Supplies

Assorted handpainted and handmade papers, including many sheer papers in whites, creams, grays, and light blues
300 pound watercolor paper, 8.5" x 13.5", for the backboard
Polyvinyl acetate adhesive or acrylic matte medium/gel
1" paint brush for applying adhesive
Rubber brayer
Scissors

## Here's How

1. **Prepare.** Cover your work surface with paper or plastic and assemble your supplies. Assemble an assortment of papers to represent the canyon walls, water, and sky.

2. **Plan.** Since this is a rather complex composition, think about the space you will use for each section of the collage. You can sketch your plan lightly on the backboard. (See the end of the instructions for this collage for my drawing.)

3. **Lay the sky paper(s)** across the top of the backboard. Because the sky portion is small, I used a single piece of paper. You could horizontally layer several papers or use an interesting handpainted paper.

4. **Create the canyon walls.** Begin layering strips of papers vertically up both sides of the backboard, creating the canyon walls. Use heavily textured papers to lend a rough look to the canyon.

5. **Select a base color** for the back wall of the canyon—the place over which the waterfall flows. (I used a medium to light tone.) Lay this paper down the backboard, tearing across the bottom to establish the horizon line of the river. (You will add several layers on top of this later.)

*continued on page 48*

## Hints & Tips

- It is easy to lose sight of the needed shading when working up close on this collage. Periodically, prop up the collage and step across the room from it to gain perspective.

- Don't be afraid to add more and more layers of paper—the many layers of sheer paper and their translucence add depth to the waterfall and the water.

- For very, very fine splashes of water against the canyon walls or rocks, wet mulberry paper, pull the heavy fiber from the paper, and glue it to the scene.

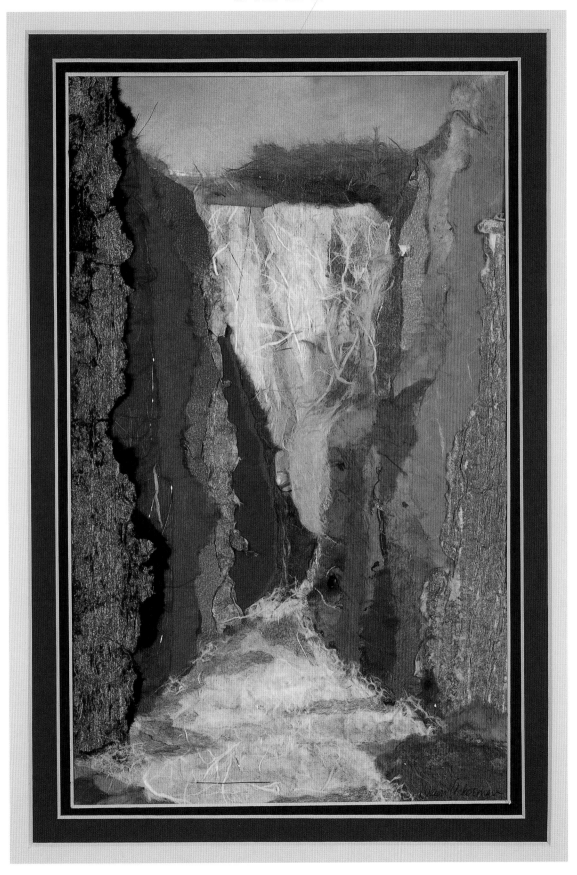

*continued from page 46*

6. **Cover the bottom.** Using a medium-tone gray or blue-gray paper, cover the backboard from this horizon line to the bottom. This provides the under color for the water in the canyon. (This establishes the base for the water—you will layer more papers over this one later.)

7. **Tear.** Holding the strips of the canyon wall on the backboard with one hand, carefully tear the top and bottom edges to create the line at the top of the canyon (these are relatively horizontal lines). Then, following the same technique, tear the bottom edges where the water comes up to the canyon walls. (These lines create the image of the river turning.)

8. **Glue.** At this point, you should have a good overall composition for the scene, despite needing more detail in the waterfall and river. Glue the pieces in place. Look at the shading of the canyon walls to be sure that it looks like the light is coming from the top of the canyon and that the shadows deepen as the canyon recedes.

9. **Trim.** Trim the edges of the collage to establish clear boundaries.

10. **Create the waterfall.** Working with sheer papers in whites, creams, tans, and peaches, use small narrow strips to create the waterfall. Glue each piece of paper as you go, building one paper on top of the others, keeping them vertical to enhance the sense of water falling. Using a heavy hand with the adhesive will make the sheer papers very transparent; use this to help blend the papers together. Apply adhesive to the tops of the sheer papers if needed. Layering the light papers creates a streaky look that gives the impression of water moving.

11. **Add details.** Add details to the water using gray, light blue, and white papers. Decide where you see shadows in the water from the canyon walls; these will remain the darkest water areas in the water. Using small pieces, begin layering papers on the water. Glue as you go, saturating the paper with adhesive to achieve a transparent look. Keep layering the papers (primarily horizontally across the backboard) to give the illusion of water. Don't worry about the edges that come to the canyon walls; they will be done last.

12. **Add rocks.** Add one or two rocks to your scene by tearing one of the darker papers used on the canyon wall (or a paper in that same family of colors) in the shape of a rock that would be visible above the water line. Glue in place. Cover the bottom edges with water papers, using slightly darker shades to create slight shadows and maintain the dimension of the scene.

13. **Create the edges of the water.** Along the canyon walls, create edges that look like the water is in turmoil. Use very small pieces of white lace or unryu papers and glue them along the edges of the water, overlapping the edges of the canyon walls. Leave the edges loose where they overlap the canyon, and glue them well into the water. Blend these into the water.

14. **Re-evaluate the entire collage.** Make sure that the canyon is well shaded, that the water has depth, and that the waterfall has movement. Add more papers as needed. (At the end of this collage, my water probably had a dozen layers of sheer papers in it.)

15. **Trim** any papers that extend beyond the backboard. Allow the collage to dry completely. ❧

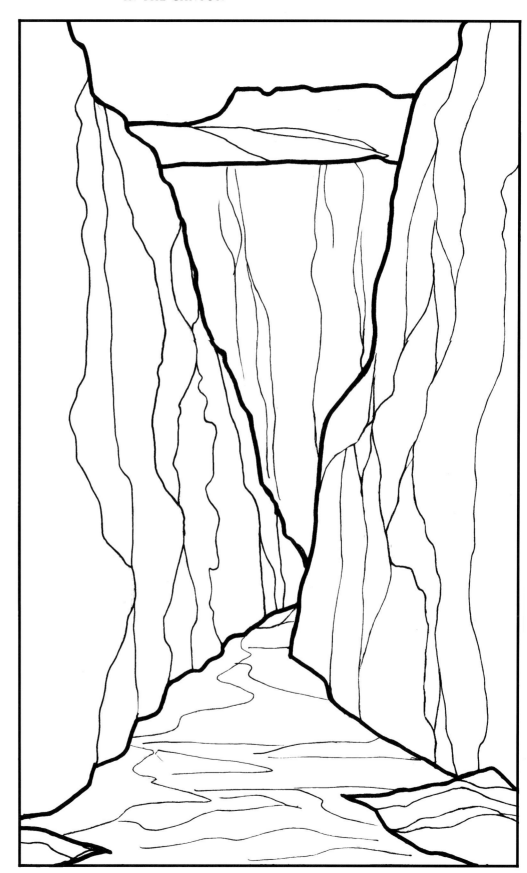

*This outline could be used to create an underpainting to help you construct your own canyon waterfall.*

*Pattern for "In the Canyon" Enlarge to 147 % for actual size*

# Vigil Light
## Collage with Pressed Flowers

*"Art takes nature as its model."*

— Aristotle

This project uses a very simple layered paper collage technique to create a background for dried flowers, which are the focal point and create the foreground. Look around for interesting flowers, leaves, or grasses that can add interest to your collages. I will often grow my own flowers, thinking in the spring about what type of flowers will dry beautifully.

Unlike other collages, you are looking to keep the colors in the same tones, not too bright or too dark, and you do not want much texture in the background. This collage relies on the subtlety of the shading to keep the collage interesting yet not overpowering to the

dried flowers. I like to use sheer papers because overlapping blurs the colors together.

Use papers of the same weight to keep the collage flat and tight to the backboard. Highly textured papers tend to come forward in the collage rather than recede into the background.

When working with sheer papers, use a very light hand with the glue but cover the entire surface. Too much glue will saturate the papers and can make them virtually disappear. If your glue is too thin, this can occur as well—either let the glue sit out for a while to thicken or apply the glue and let it set until tacky, rather than wet, and then apply the papers.

## Supplies

Assorted pastel mulberry/unryu handmade papers
Dried pressed flowers
300 lb. watercolor paper, 6" x 12", for the backboard
Polyvinyl acetate adhesive and/or acrylic matte medium/gel
1" paint brush, for applying adhesive
Rubber brayer
Scissors

## Here's How

1. **Prepare.** Cover your work surface with paper or plastic and assemble your supplies. Assemble an assortment of pastel papers, all of comparable weight. (I used mulberry/unryu papers.)

2. Beginning with the papers at the horizon line (I used white), **use torn strips to shade** the sky to the top of the backboard, then shade down into rolling hills to the bottom.

3. **Glue** the papers to the backboard, ensuring that the edges are adhered tightly. Use a brayer to ensure that each strip of paper adheres well.

4. **Trim** the edges of the papers that extend beyond the backboard.

5. **Arrange dried flowers** on the surface of the collage, creating a foreground. I used the dried salvia—the flower along with the stem and a few leaves. Just as easily, you could use separate components to create the image.

6. **Apply adhesive** to the surface of the collage and gently press the dried flowers in the glue to adhere them. (Dried flowers are fragile, so use a light touch.) If you like, you can paint the surface of the dried flowers with the adhesive to strengthen and protect the flowers.

### Tips for Drying Plants

- Use a flower press. I have a wonderful little flower press that works in the microwave and dries plants in a matter of minutes, rather than weeks. I also use a traditional flower press, purchased at my local craft shop, that has a wooden external surface, screws at the corners, and cardboard and papers in between to separate layers of flowers and leaves.

- Pressure is important in pressing plants, since they need to be kept very flat during drying. If you choose to press them between the pages of a book, make sure there is plenty of weight on top to create sufficient pressure.

- Make sure that the flower or plant you want to press is dry to the touch or it may mildew. (This is less critical with the microwave press because of the short time involved.)

- Choose plants and flowers that are not too thick or they will not dry flat. For example, I would not choose roses, but I would choose pansies.

- Often I find interesting plants, wildflowers, grasses, and leaves on nature walks that I wouldn't necessarily want to grow in my own back yard. Weeds can be very interesting!

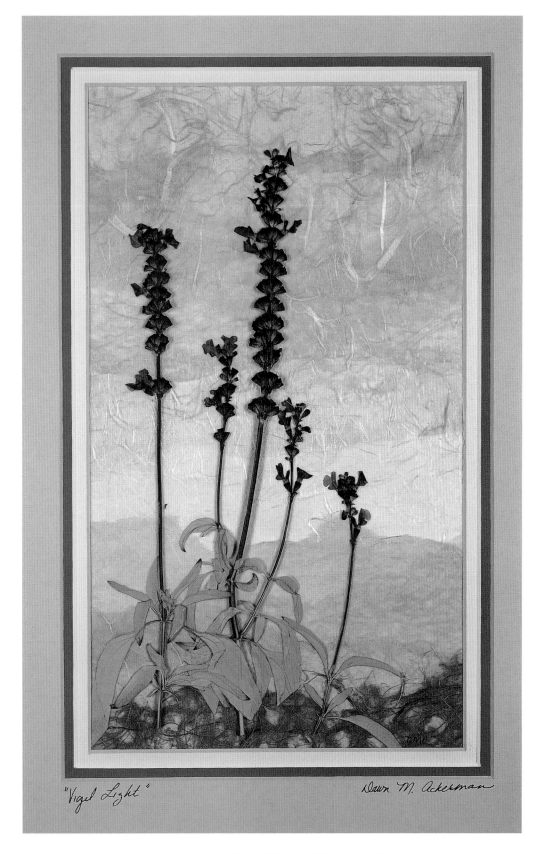

"Vigil Light"

Dawn M. Ackerman

# Landscape Collage Gallery

On the following pages are photos of a variety of my landscape collages. I hope these will inspire you to design you own collage art. The measurements given for each piece of art does not include the mat. Use these measurements to determine what size backboard you will need.

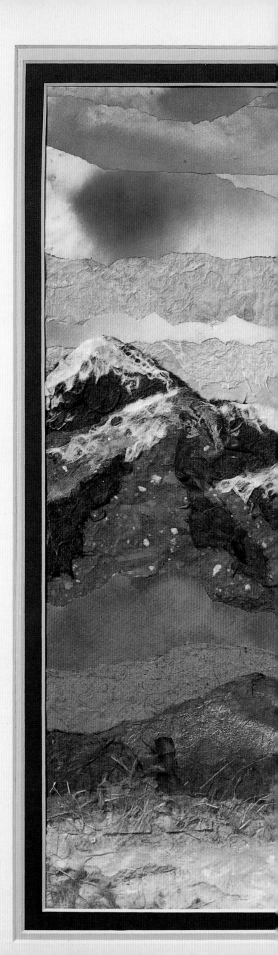

*Spring Meadow • 25" x 21"*

Notice there are three sections to this collage: the sky, the mountains, and the meadow. Spattering white and yellow paint on pale green unryu papers creates the impression of fields of flowers in the meadow. The trees at the edge of the meadow are created with a darker green ogura lace paper. This collage was done to display on the set of *The Carol Duvall Show* in 2001.

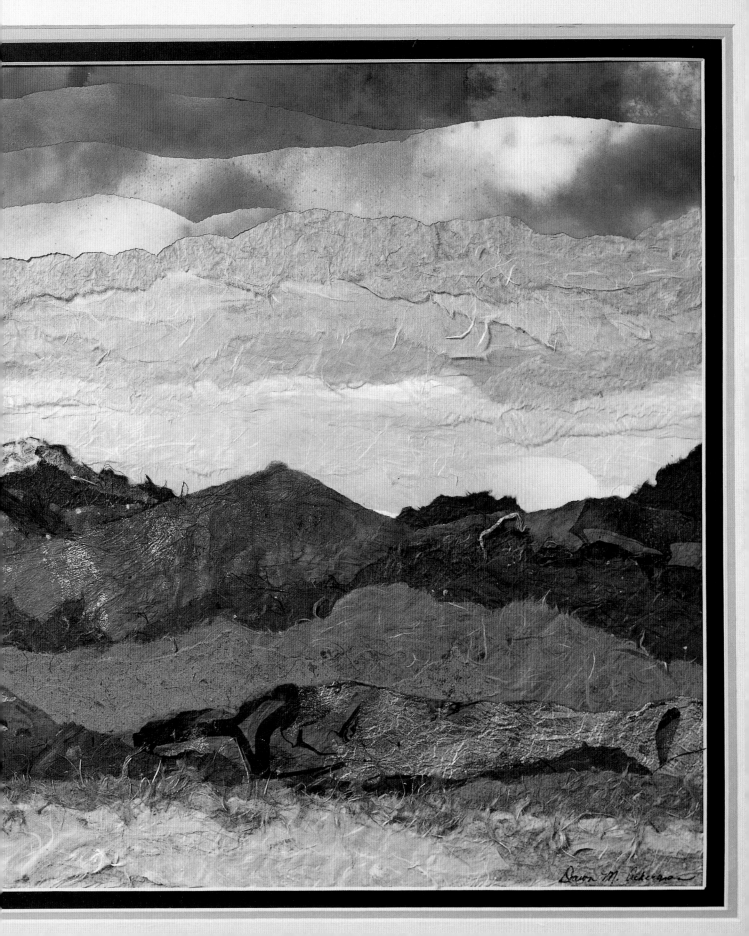

*Snow in the Summer* • *25" x 21"*

The sky in this collage steals the show with the vivid colors of
a summer sunset. The mountain is rugged and still has bits of
snow high on its peak. This collage was completed as a set
decoration for *The Carol Duvall Show* for 2001.

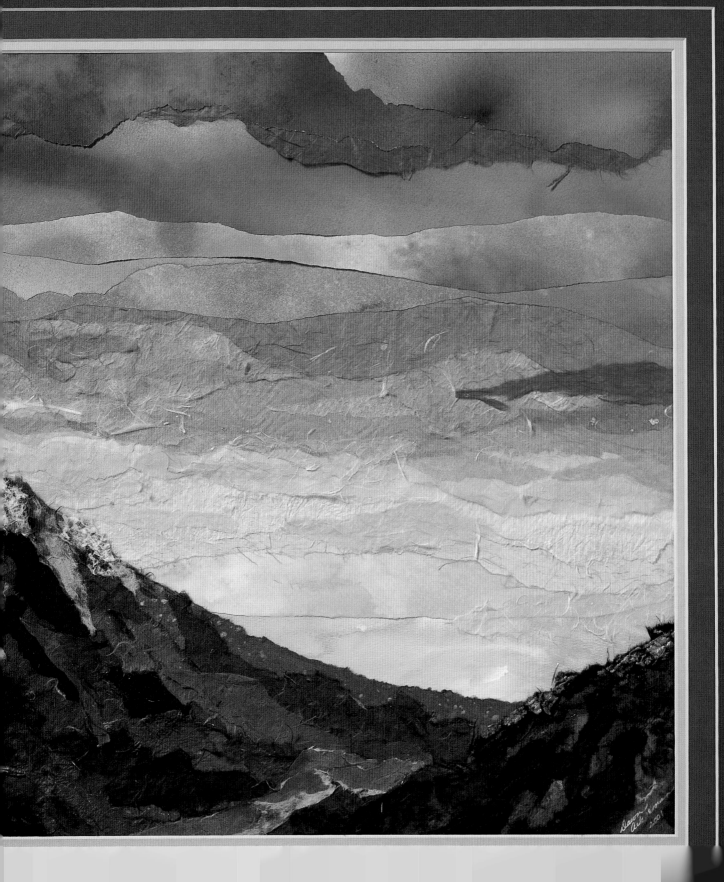

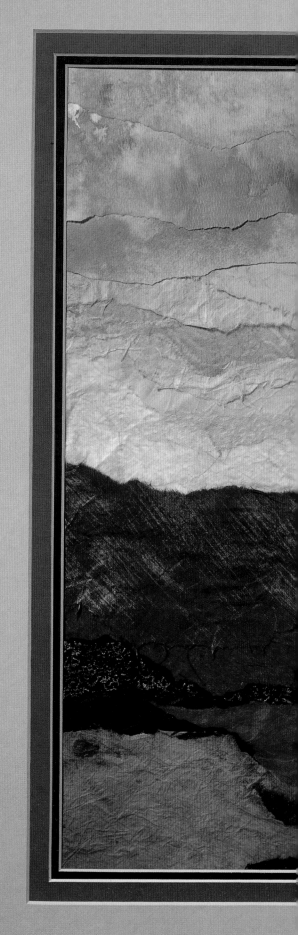

*Desert Images • 25" x 21"*

Created for the set of *The Carol Duvall Show*, this collage
displays the colors and heat of the desert. The edges of the
individual hills and plateaus are made clearer through the
careful use of black papers among coppers, oranges, and rusts.

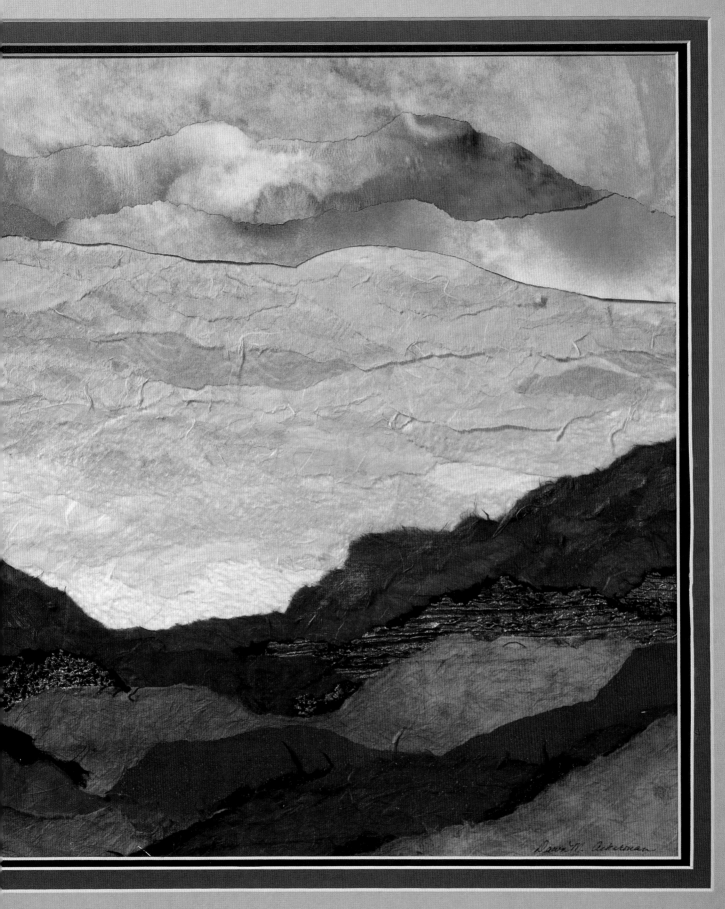

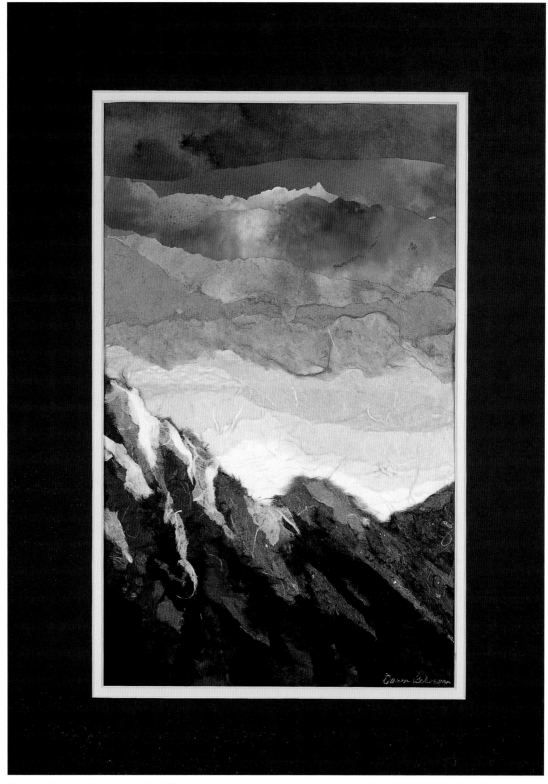

*Snow-Capped Peaks • 11" x 17"*

This collage was created as a study of snow on a rugged mountain, where the snow was very, very white and the crevices on the mountains were very, very black.

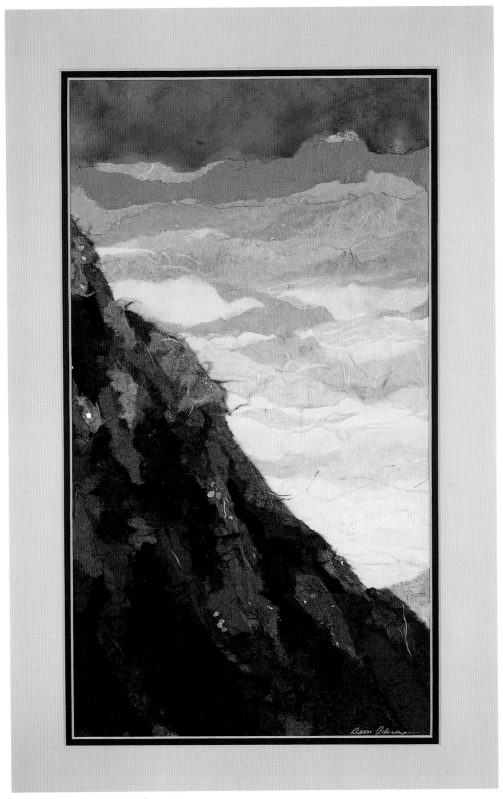

*Black Mountain • 11" x 19"*

This mountain is composed of myriad browns, blacks, grays, and even greens and blues. A little light is captured with gold mineral flakes, which were added one at a time.

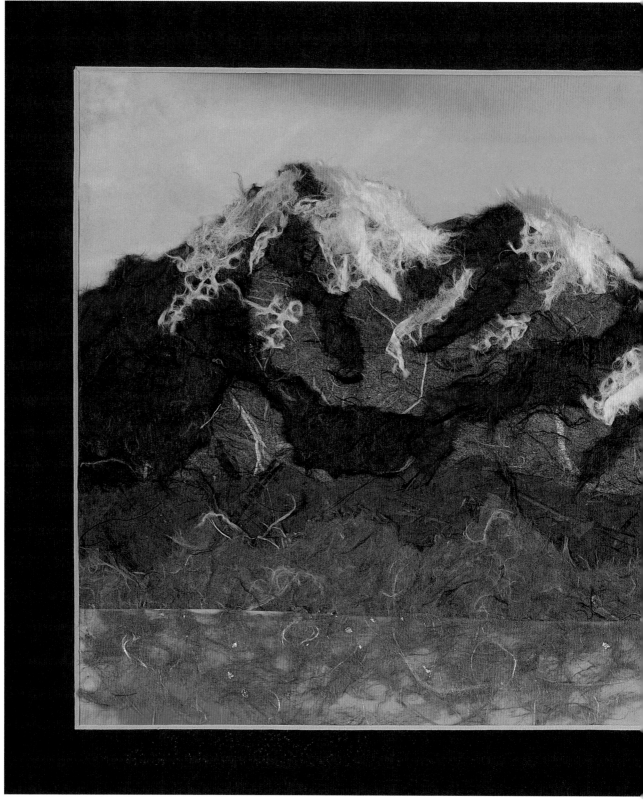

*Sunset Fire • 18" x 9.5"*

Sometimes a sunset has colors that are just unbelievable—when we see paintings of them, they don't look real. I wanted this collage to pop with color—color in the sky and color as it might be reflected in water in the foreground.

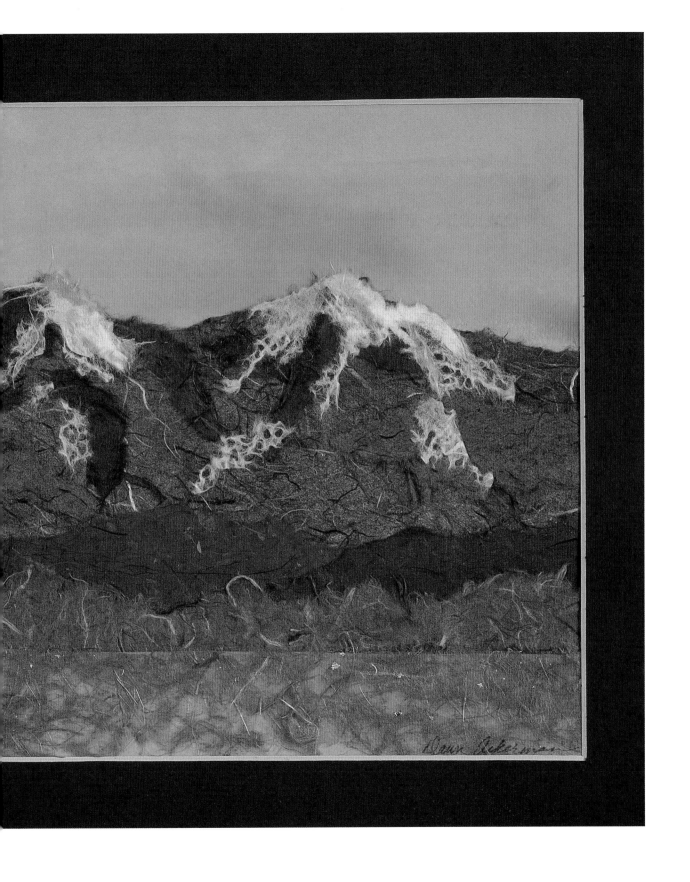

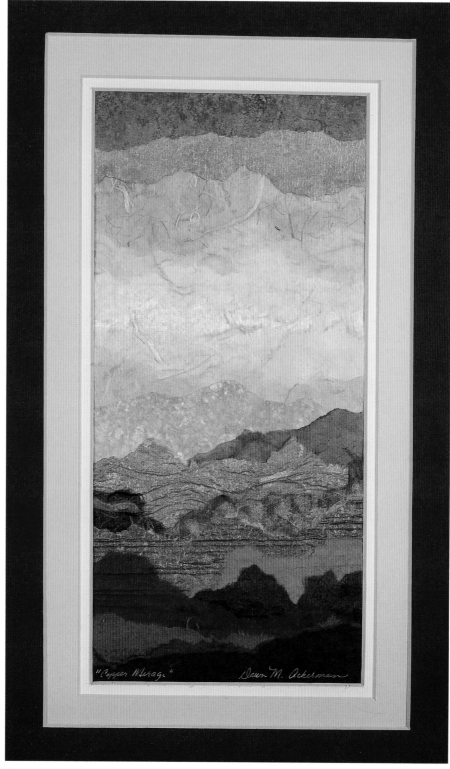

*Southwestern Days • 7" x 13"*

    The hot desert colors and bright blue sky are captured in this collage. The heavily textured handpainted papers in the foreground add interest to this simple layered paper collage.

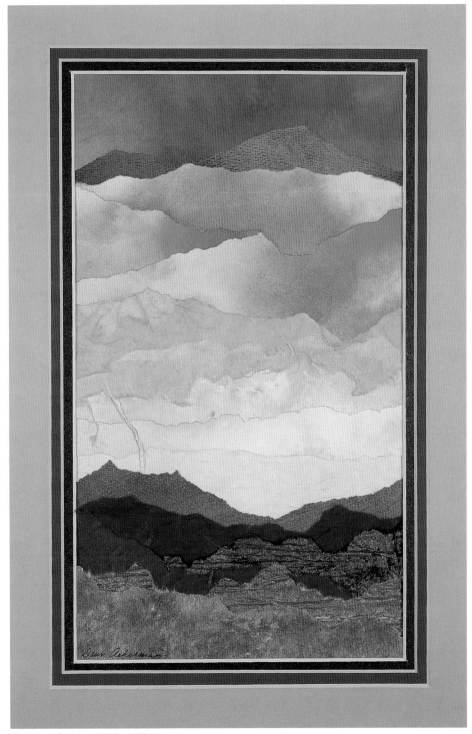

*Sedona Skies • 7.5" x 13"*

The handpainted papers of the sky make this collage interesting, while the simple foreground actually takes on a supporting role.

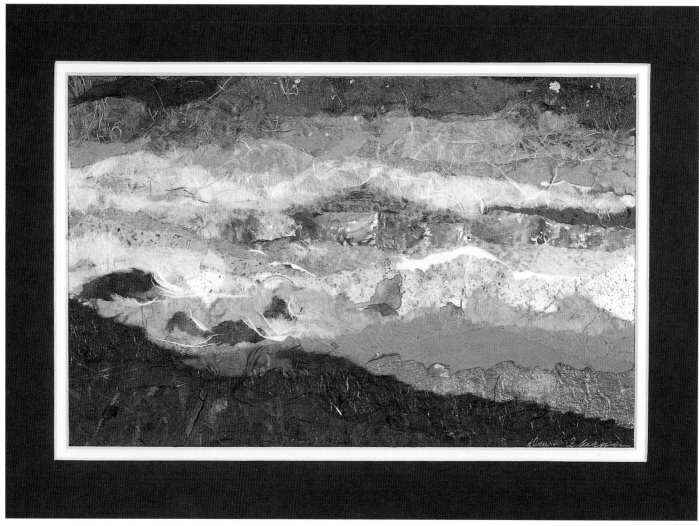

*The Coast • 14" x 9"*

This is an unusual collage for me because no sky is visible.
Instead, the ocean coast is seen as an inlet against a backdrop of
vegetation.

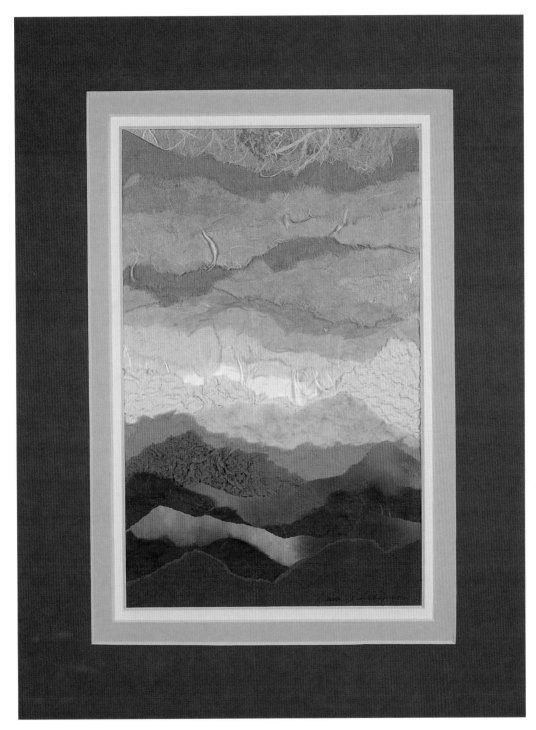

*Mirage • 7" x 11"*

    The distinction between the foreground and the sky is blurred through the use of common tones of colors shaded to white at the horizon line. This was an unintended result—my original layout had the peach color as a part of the sky. As I continued to work on the composition, the peach shifted and became part of the foreground. I liked the result.

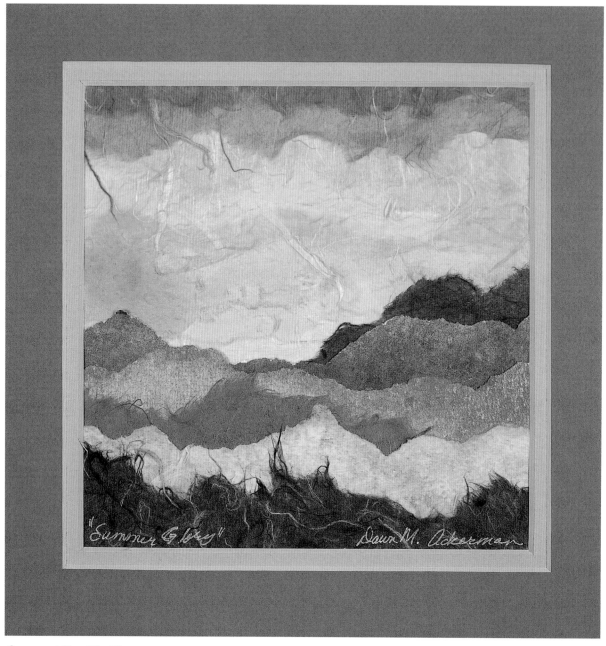

*Summer Hills • 7" x 7"*

This is a simple layered paper collage, completed exclusively with horizontal strips of papers. Color and line give an interesting effect.

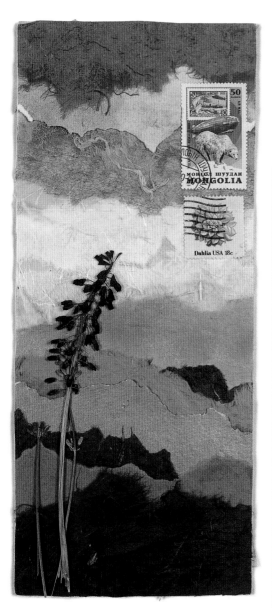

*Mountain Travels • 4.75" x 11"*

This basic layered paper collage has added interest with pressed dried flowers and color-coordinated postage stamps.

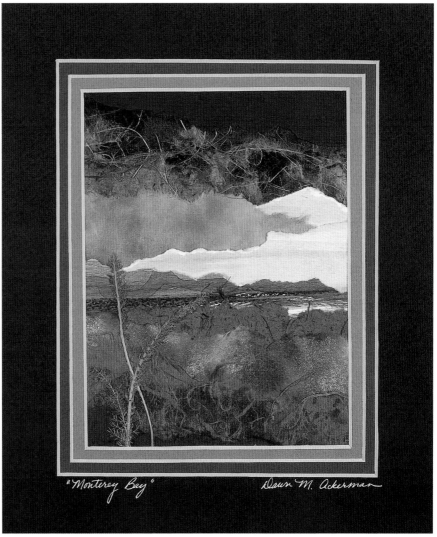

*Monterey Bay • 5.5" x 7"*

There's no sky in this collage—it is layered from the top straight down to the bottom. Green ogura lace paper adds texture and lacy dried leaves bring the foreground in close.

# Abstract Collage

*"The job of the artist is always to deepen the mystery."*

— Francis Bacon

*A*BSTRACT COLLAGE DOES NOT SIGNIFICANTLY DIFFER FROM OTHER FORMS OF ABSTRACT art. For an abstract collage, you endeavor to create an interesting mixture of color, line, and composition using papers and other relatively flat elements. This section explores techniques I use for abstract collages.

Abstract collage is non-representational. It does not reproduce the specifics of any particular image, but instead seeks to create a grouping of elements that evokes a particular emotion or feeling or impression. It may leave you with an impression of a particular item or scene, but it is not a realistic likeness of that item or scene. Instead, it may rely on a few lines or colors to create an impression or use specific colors and lines to evoke a feeling. All this is up to you, as the artist. You can decide whether to use embellishments to make the image more realistic or specific, or to leave that to the viewer's imagination.

An abstract collage may evoke different responses in different people, and one exciting aspect of abstract collage is that often the end result surprises you, the artist. Some of my abstract collages create the impression of representational art.

## Hints & Tips

- This is a great place to use those watercolor papers that you covered your work surface with when you were painting papers. They are typically very colorful and interesting. When I'm having a hard time getting inspired, I often start with these papers because they immediately introduce interest and color.

- I like to create direction in my collages and am told most of my abstract collages have a diagonal line somewhere. Choosing a direction for your papers to flow makes the composition come together more easily.

- This is a great project for using scraps you've trimmed from the edges of other collages. Even little pieces that are glued together can be interesting. I often leave the cut edges exposed to show a sharp line in the piece. And, of course, keep the scraps that you trim from the edges of your abstract collages and use them in your next piece!

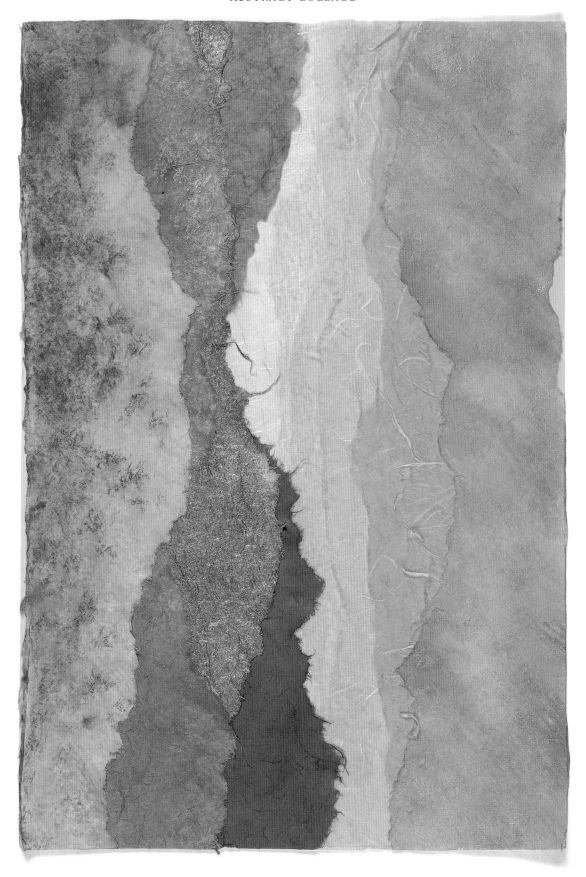

# Abstract Project
# Step-by-Step Technique

*"To create one's own world in any of the arts takes courage."*

— Georgia O'Keeffe

Abstract collages, for me, are about playing with paper—using color and form to evoke an emotion or trigger an impression. They are about combining colors and creating interesting lines. Find a special piece of paper that inspires you and start there, or choose a concept or emotion you want to express. (I find my abstract collages reflect my mood and feelings at the time of their creation.)

For this project, I used many different colors, primarily in blues, greens, and purples that, for me, represent coral reef and tropical fish colors. While these colors are the primary theme, they are not the only colors.

I like to keep many, many papers on hand, pulling the primary colors and leaving other papers readily available. With these collages, I often find that my concept shifts as I work, and the collage ends up with very different colors than those I originally planned. Keeping the entire palette of papers available lets you maintain fluidity in your thinking as you work.

## Supplies

Assorted handpainted and handmade papers
300 pound watercolor paper, 10" x 10", for the backboard
Polyvinyl acetate adhesive or acrylic matte medium/gel
1" paint brush, for applying adhesive
Rubber brayer
Scissors
Assorted embellishments (metallic threads, mica flakes, crushed minerals, dimensional fabric paints)

## Here's How

1. **Prepare.** Cover your work surface with paper or plastic and assemble your supplies. Assemble a wide assortment of papers.

2. **Select the starting point.** In abstract collages, each paper is glued immediately to the backboard, building the finished piece, starting at a corner. Begin by selecting a single paper to get started. Tear the piece that will be glued in the corner. It is not important which corner you start in (I usually start at the bottom left). You can start in the middle or any other spot that works for you; the technique will proceed the same way, regardless.

3. **Glue.** Using your adhesive brush, apply glue to the backboard and adhere the first piece of paper to your collage. Make sure that the paper comes out to the edges of the backboard; any excess will be trimmed later. The inside edge of this paper will be overlapped with other papers, so be sure it is glued down well.

4. **Continue to tear and glue.** Working from the initial piece of paper, tear papers and glue them to the backboard. Brush glue over the top of the papers to help adhere edges. Evaluate the overall look of the piece as you go. The size of the pieces can vary—one paper might be several inches wide and span most of the length or width of the backboard; others may be as small as 1/4" wide by an inch or two long. Look for interesting lines and shapes. Make sure that you like the way the colors lay together. This type of collage is very forgiving; if you glue a paper and decide you don't like it, cover it up, completely or partially, with other papers—a composition that looked interesting may be discordant as more papers are added.

5. **Trim.** When the backboard is completely covered with paper, turn it over and, working from the back, use sharp scissors to trim the excess paper that extends beyond the edges of the backboard. This gives the composition clean edges (better for evaluating the overall collage).

*continued on page 72*

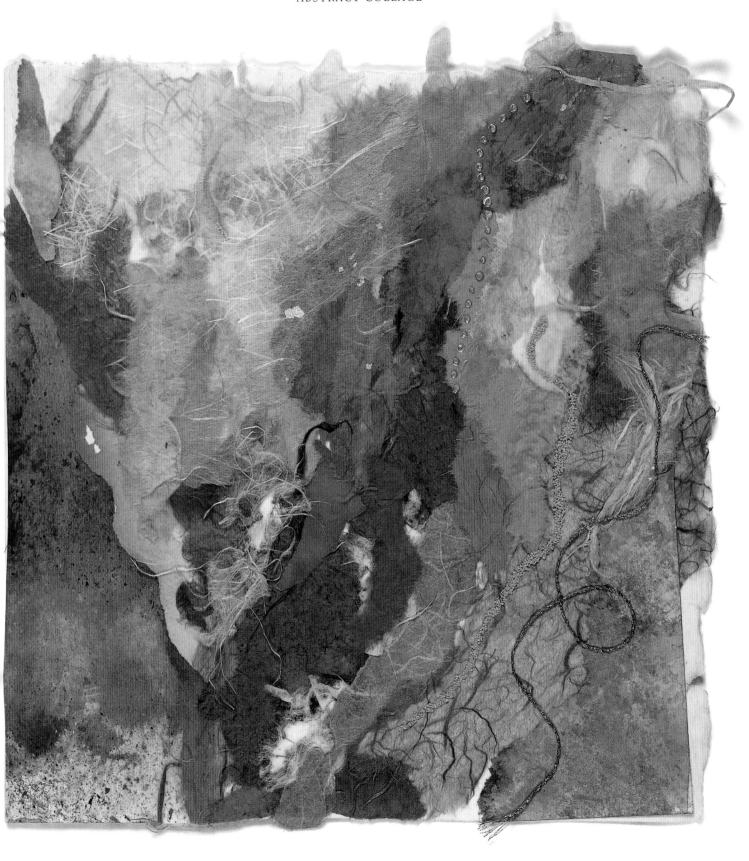

6. **Evaluate.** Set your collage upright across the room so you can see it from a distance. Look to see if the overall composition works. Are the lines interesting? Do the colors flow together well? Is there a good range of colors?

7. **Adjust.** Don't be afraid to add more layers—I find people often stop too soon! A composition becomes more interesting and richer with continued attention to details. Add papers to enhance the composition, layering them over the base layer of the collage.

8. **Embellish.** Add embellishments, if desired. (See "Adding Embellishments to Abstract Collages.")

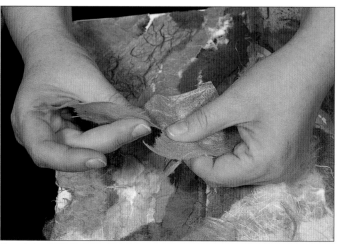

Step 2: Tearing a piece of handmade paper.

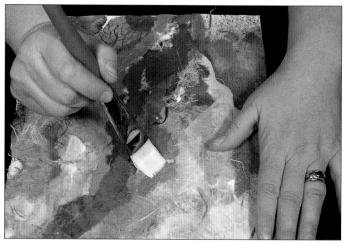

Step 4: Securing the paper by brushing more glue over the top.

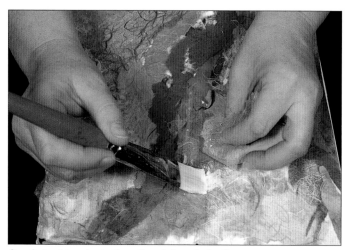

Step 3: Applying glue to the collage before placing the paper.

# Seasons

*Project pictured on page 74*

*"Art is not what you see, but what you make others see."*

— Edgar Degas

This collage represents my interpretation of the seasons, capturing how colors shift and change throughout the year. While this is actually four individual collages, it is the common line and movement of each piece that makes them one.

This project allows you to explore the vision you have of the colors of each season. For spring, I chose the yellow of daffodils, the green of new foliage, and the blue of skies. Summer was captured with the bright, hot colors of the flowers in my garden—pinks, purples, blues. To capture the colors of fall, I used warm coppers and browns, rich greens, and vivid orange. For winter, the short days and long nights brought blacks in contrast to the cold blues and whites of winter.

## Supplies

Assorted handpainted and handmade papers
4 pieces 300 lb. watercolor paper, each 5" x 11.5", for the backboard
Polyvinyl acetate adhesive or acrylic matte medium/gel
1" paint brush, for applying adhesive
Rubber brayer
Scissors

## Here's How

1. **Prepare.** Cover your work surface with paper or plastic and assemble your supplies. Assemble an assortment of papers, grouped by color according to the seasons they represent (to you).
2. **Select papers.** Select a set of papers for each season. The colors and papers you choose reflect your thoughts and feelings about each season.

*Follow the remaining steps to complete the section for each season, then evaluate and adjust to create a harmonious whole.*

3. **Select a single primary paper** and glue this paper to the backboard. I find it easiest to work from a corner of the backboard,

moving up and across as I adhere more papers.

4. **Continue tearing and gluing papers** across the backboard, overlapping the edges of the papers and ensuring that the entire backboard is covered. Look to see how each paper blends or contrasts with the papers beside it. Watch for the creation of interesting lines. Be sure to vary the texture of the papers as well as the shapes and sizes.
5. **Trim** the collage along the edges of the backboard. This helps you to get a sense of the overall composition.
6. **Evaluate.** When the base collage is in place, step back and evaluate the overall composition. Layer more papers as needed to create interesting lines and a sense of movement.
7. **Trim** any papers that extend beyond the edges of the backboard.

*Repeat steps 3-7 for each season. Remember to repeat the overall directional movement and lines in each season to give cohesion to the whole.* ❧

### Hints & Tips

- Because each collage section is done individually, start with the season that most inspires you. That inspiration will set the stage for the other seasons.
- I find my abstract collages vary depending on my own mindset and mood. To create a set of four collages that work together, I created them one after the other in a relatively short time frame.
- Don't get married to a specific piece of paper for any collage. Some of my favorite papers—the ones I started with—are not in the final piece or are completely covered by other papers.
- While I like the clean look of paper only on these collages, you could add embellishments to enhance the lines or textures. Keep in mind that if you embellish one season, you need to embellish the others to keep commonality across the whole.

# Abstract Collage Gallery

The sky is the limit when it comes to abstract art. Colors and textures play an important part in the design of your collage. Following are photos of some of my abstract art. The measurements indicate the backboard size, excluding mat.

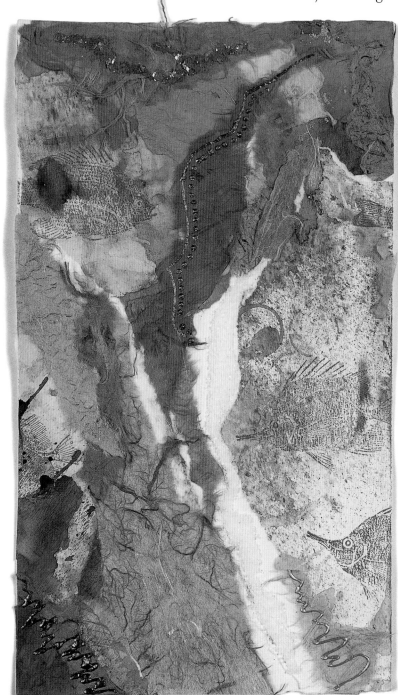

*Fish Prints • 7.5" x 13"*

The fish images on this collage were added after the collage was completed. I used rubber stamps that emulate nature printing with actual fish. Because ink often bleeds or blurs on handmade papers, I stamped only the handpainted watercolor papers. A thick layer of beads adds dimension to the white crevice in the collage.

▶ *Jellyfish • 12" x 17"*

This abstract collage, upon completion, looked remarkably like a jellyfish. The threads and dimensional fabric paints were added to enhance the impression of a jellyfish in the ocean.

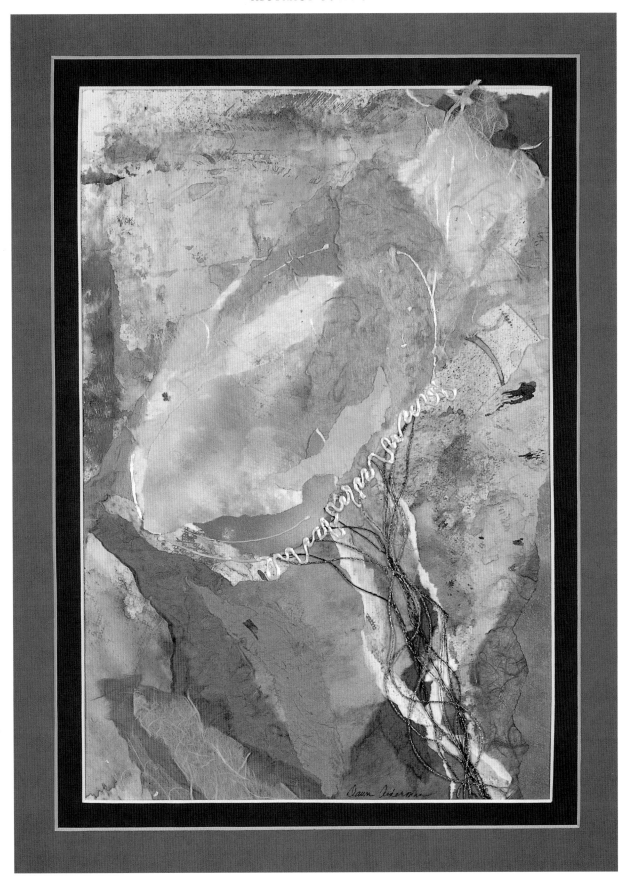

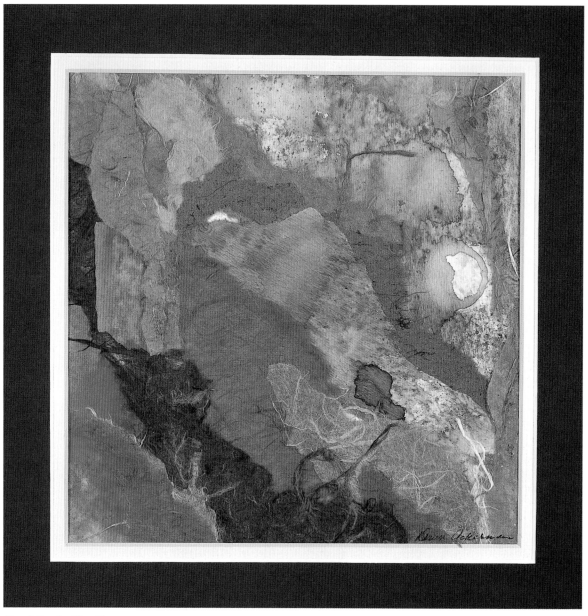

*Coral Reef • 9" x 9"*

This collage began by using a section of watercolor paper that was my working surface for painting papers; you can even see the impression of a bottle that was sitting on the paper if you look closely. I am often inspired by the unexpected results of these papers.

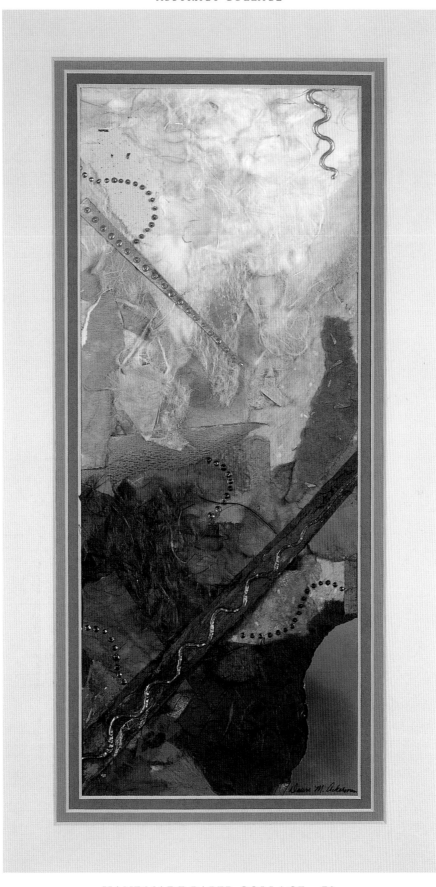

*Iris • 7" x 14.5"*

Inspired by the glorious spring array of purple irises in my garden, this collage reflects the many colors I could see. Notice the use of cut edges on some of the papers; they were trimmed from earlier collages.

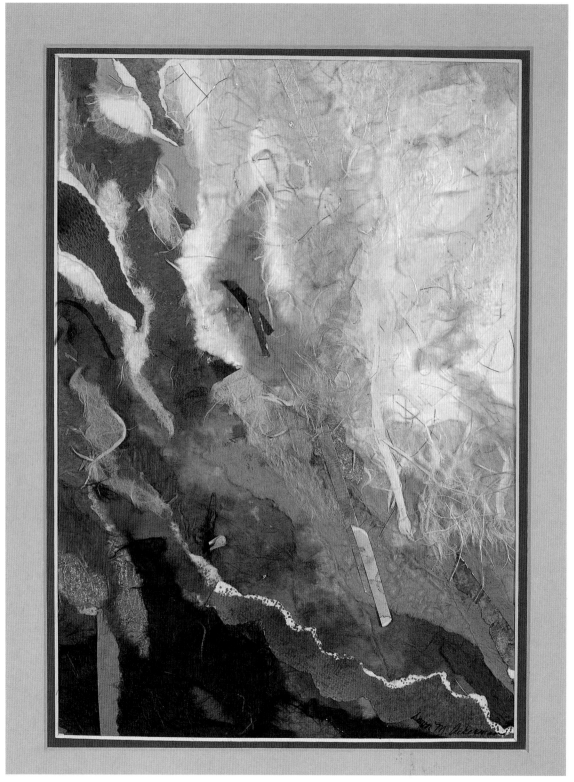

*Angel's Flight • 10" x 14"*

When I trim my landscape and abstract collages, I keep all the pieces, even the tiniest scraps. This collage was created using only scraps left over from other collages.

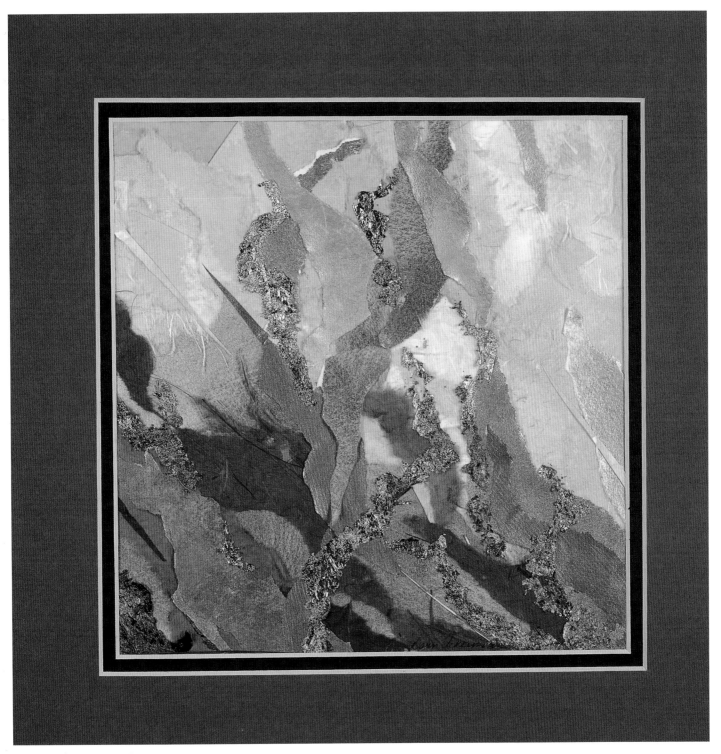

*Solar Flare • 10" x 10"*

   The interest in this collage is created with gold and composite metal leafing. The
leafing catches the light and enhances the undulating lines of the papers.

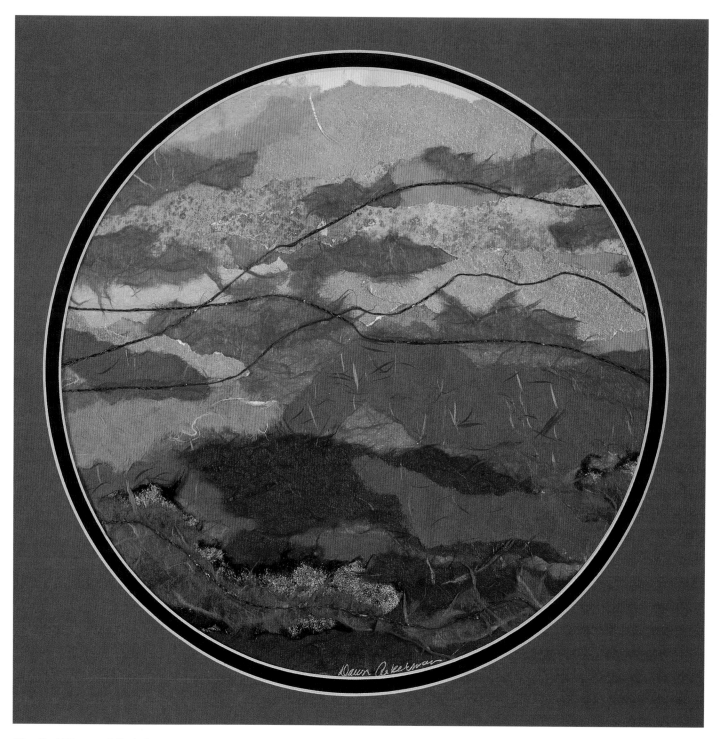

*The Red Planet • 11" circle*

Red metallic threads add to the impression of curving bands of color, horizontally layering this collage.

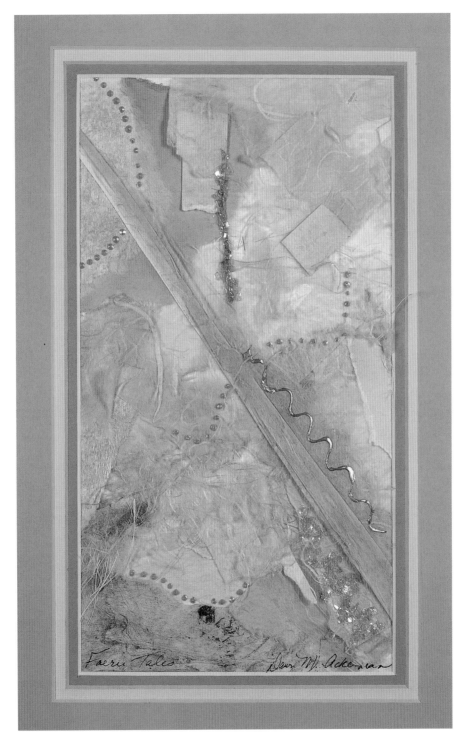

*Faerie Tales• 7" x 12"*

    Here is a collage that uses scraps trimmed from the edges of other collages to create a pastel collage. It reminded me of the princesses' dresses in my daughter's fairy tales books. The addition of dimensional dots of fabric paint enhances the delicate look.

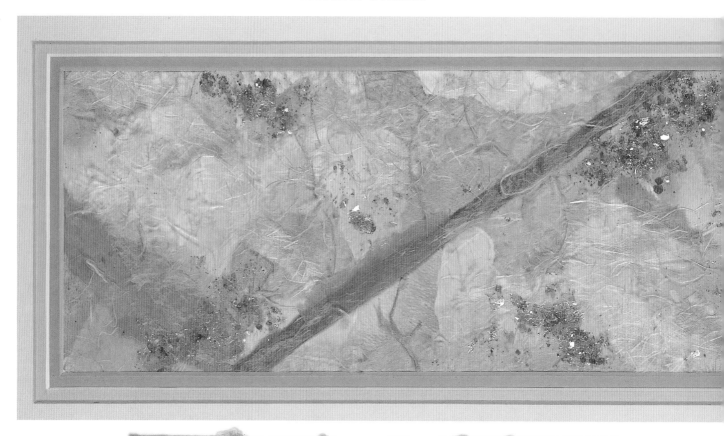

*The Gathering •*
*11.5" x 8"*

This collage exclusively uses vertical strips of papers, yet leaves a distinct horizontal line. My daughter thought it looked like a group of people, hence the title.

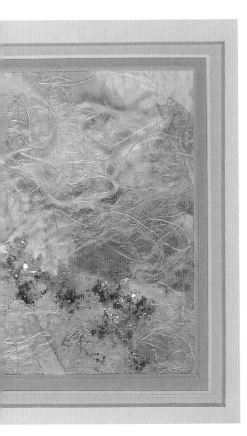

*Peach Chiffon • 18" x 7"*

    This monochromatic collage uses shades of peach from very, very light to a dark coral. Colored and clear mica flakes add interest to the textures.

*Motion • 11.5" x 9"*

Made before the availability of many of today's handmade papers, this collage uses layer after layer of rice paper to create an illusion of movement.

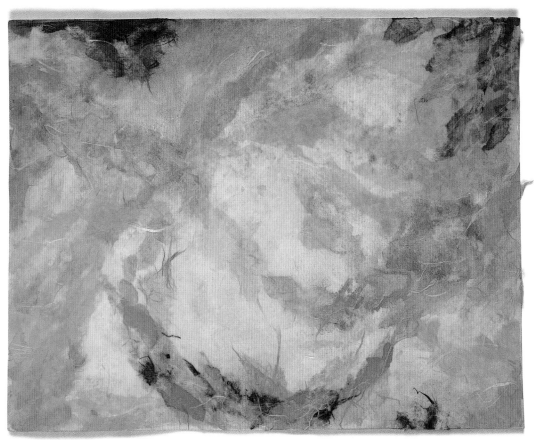

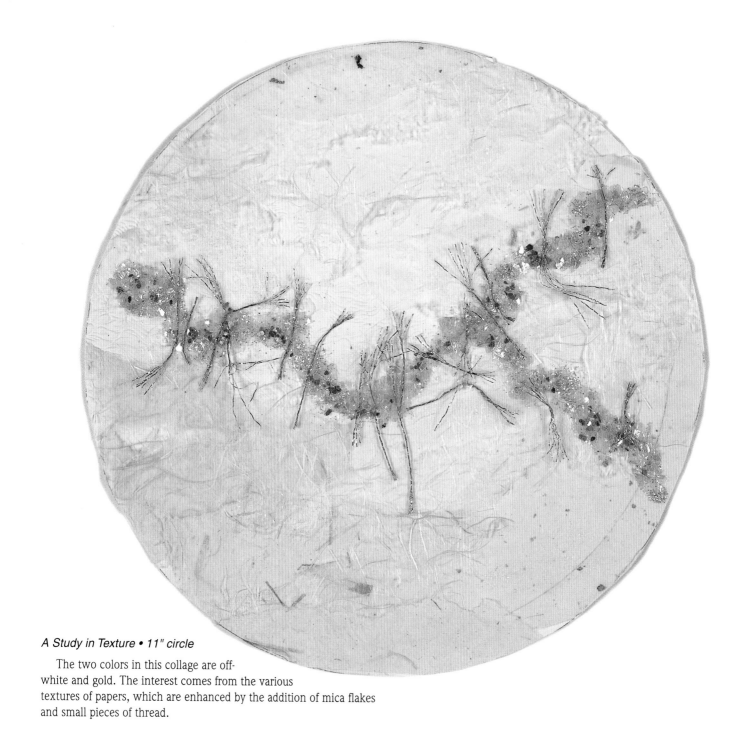

*A Study in Texture • 11" circle*

    The two colors in this collage are off-
white and gold. The interest comes from the various
textures of papers, which are enhanced by the addition of mica flakes
and small pieces of thread.

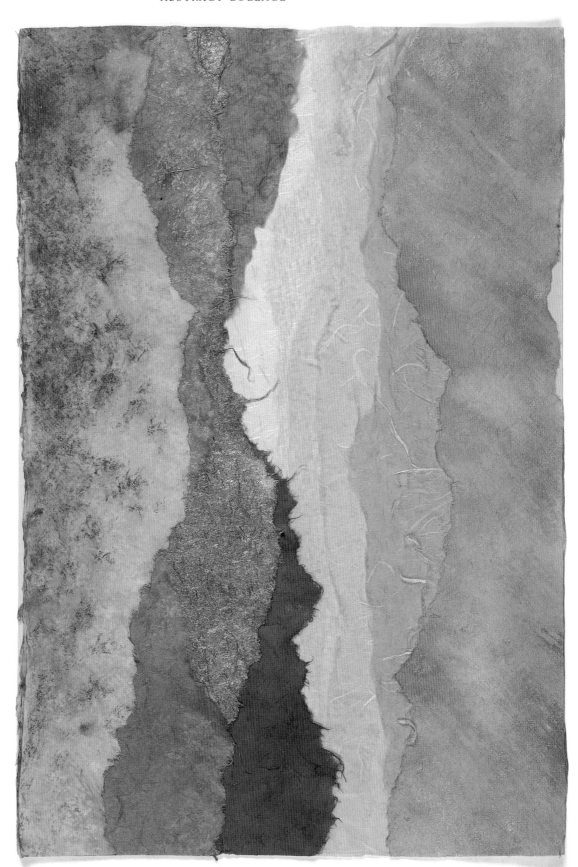

*Colors Flowing •*
*13" x 19"*

This collage looks a bit like a surreal landscape when laid on its side but was inspired by the process of hand-painting papers using liquid watercolors and acrylics. I love the way the colors flow together and create interesting lines and shadings.

# Sculptured Paper Leaves

*"The real act of discovery is not in finding new lands, but in
seeing with new eyes."*

— Marcel Proust

Nothing evokes the feeling of autumn more than colorful falling leaves.
Capturing the beauty of autumn in this project is a beautiful abstract collage
in coppers, oranges, browns, coupled with three spectacular sculpted paper
leaves. Paper sculpture is a wonderful art form that uses light scoring of
paper to enable controlled creasing to make flat paper images have dimension.

## Supplies

Assorted handpainted and handmade papers
300 lb. watercolor paper, 9.5" x 12", for the backboard
Cream card stock
Leaf rubber stamp
Brown multi-color dye ink
Copper paint pen
Metallic acrylic paints, assorted colors, for painting leaves
Sea sponge
Craft knife
Polyvinyl acetate adhesive or acrylic matte medium/gel
1" paint brush, for applying adhesive
Rubber brayer
Ruler or straight edge
Scissors

## Here's How

1. **Prepare.** Cover your work surface with paper or plastic and
   assemble your supplies. Assemble papers in colors that are
   evocative of autumn and falling leaves.
2. **Design.** Using techniques described in this book, design a simple
   layered paper landscape collage, using rusts, browns, coppers,
   burgundies in the foreground. These colors complement the colors
   of the leaves that will be added later. Trim the excess paper along
   the edges of the backboard.
3. **Stamp or trace leaves.** Using dye ink, stamp three leaves on
   cream card stock. *Option:* Draw or trace actual leaves on card
   stock, outlining the veins with a narrow brown marker. Draw a
   small branch with a single fork on the card stock.

4. **Paint leaves and cut out leaves.** Using a sea sponge, sponge
   multiple colors of metallic acrylic paint on the leaves. Completely
   cover the surface to create a shimmering autumn leaf. Paint the
   branch in the same fashion. Cut the leaves and the branch from the
   card stock. *Option:* Use multicolored card stock or use a multi-
   color dye ink pad and apply color to the card stock with a brayer.

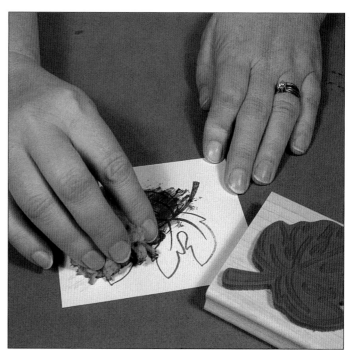

*Painting the stamped leaf with a sea sponge. The leaf stamp is shown.*

*continued on page 90*

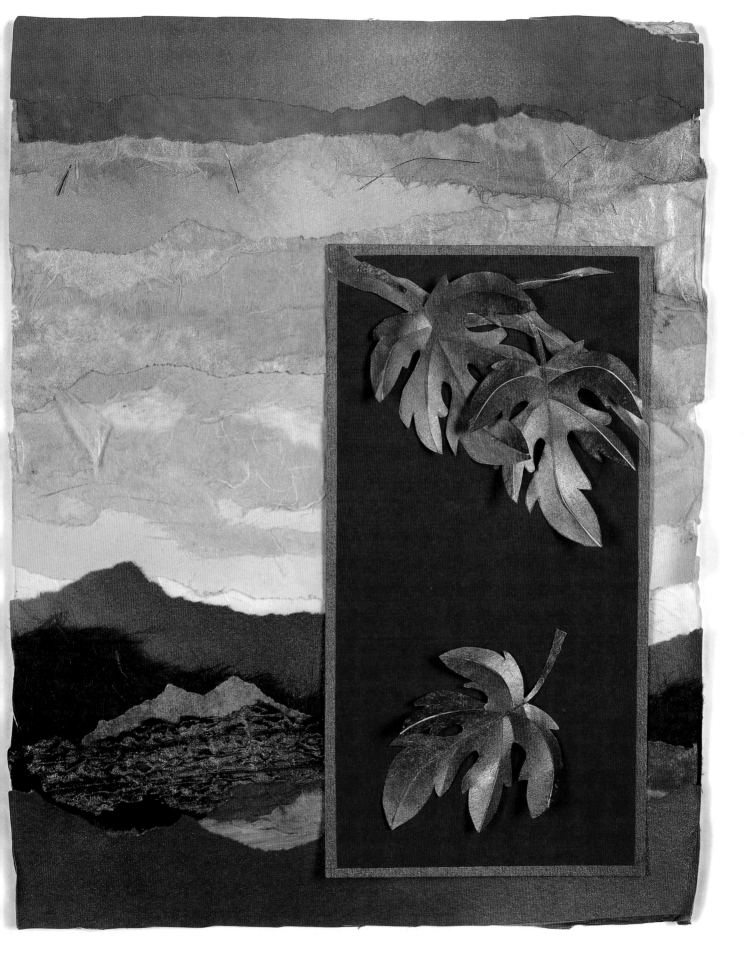

*continued from page 88*

5. **Score leaves.** Working with each cut-out leaf, lightly score the primary veins of the leaves, using a craft knife. The scoring should lightly cut the surface of the paper, without cutting through the paper. Turn over the leaf and score lightly between the lobes.

6. **Fold the leaves.** Working one leaf at a time, hold the leaf in your hand and bend the paper along the leaf's veins. Bending will crease the leaf and create something of a reverse crease along the scores on the back. Turn over the leaf and strengthen the creases on the back. Use your fingers to add curves to the lobes by bending the leaf around your finger with the creases folded. Score and fold all three leaves.

7. **Score the branch.** On the front of the paper branch, lightly score the full length of the branch with a single line along the center of the branch. Bend the branch lightly, creating a soft crease and giving dimension to it.

8. **Cut and edge burgundy card stock.** Cut a piece of burgundy card stock 4.25" x 8.5". Using a metallic copper paint pen and a ruler, edge the paper with copper.

9. **Glue branch and leaves.** Using very small amounts of adhesive, adhere the branch to the burgundy card stock. Add the leaves, using the same light application of glue.

10. **Glue the card stock.** Glue the burgundy card stock to the bottom right corner of the abstract collage. ✍

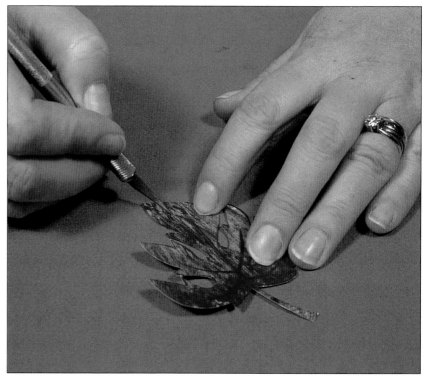

*Scoring the front of the leaf along the stamped veins. While scoring the leaves and branch, don't cut the paper into pieces, but do cut into the paper sufficiently to allow you to easily fold the paper and attain sharp lines with the creases.*

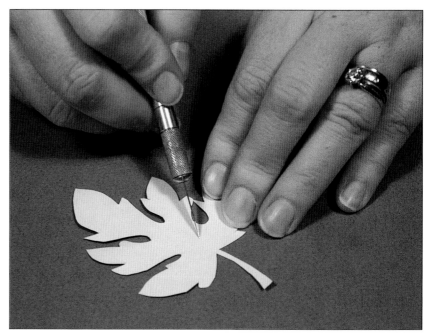

*Scoring the back of the leaf between the lobes. Using a new, very sharp blade in your craft knife allows you to score without much pressure and gives the best results.*

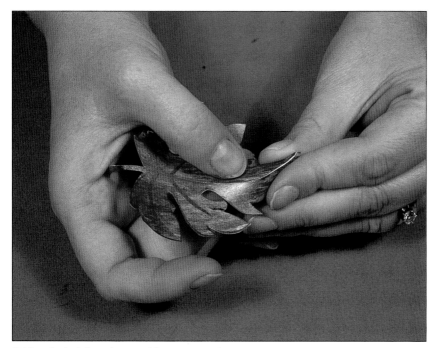

*Folding the leaf along the scored lines to give it dimension.*

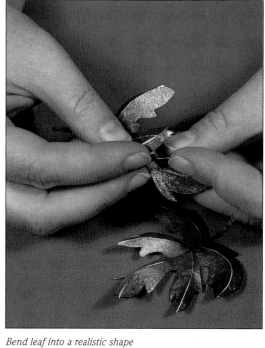

*Bend leaf into a realistic shape*

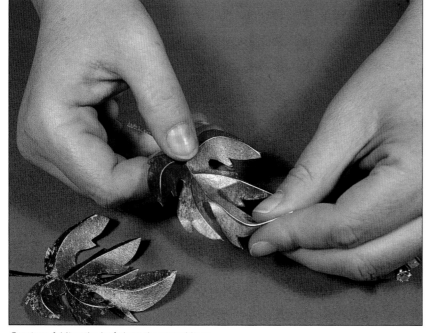

*Continue folding the leaf along the scored lines.*

## Hints & Tips

- Frame this collage in a shadow box frame that will not flatten it.
- Make this collage on a smaller scale for a beautiful greeting card.

# Boxes & Threads
## Cut-up Abstract Collage

*"Every artist was at first an
amateur."*
— Ralph Waldo Emerson

What if you work and work with an
abstract collage and you just can't get
it the way you want. Perhaps you like
the colors, but the composition isn't
right, and you are tired. (Maybe you
even want to throw it away—I certainly
have felt that way about a piece.) Here
is a fun project that lets you make
something interesting out of that
collage. An abstract collage was the
starting point for this project.

## Supplies

Abstract collage
Sharp scissors or craft knife
Threads or wires in colors that complement
    the abstract collage
300 lb. watercolor paper
Acrylic or watercolor paints
Ruler
Foam mounting tape
Strong tape
*Optional:* Beads

*continued on page 94*

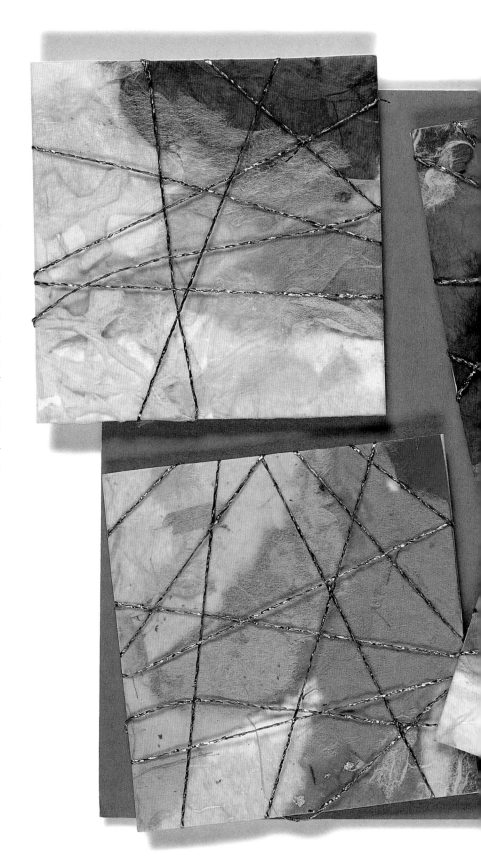

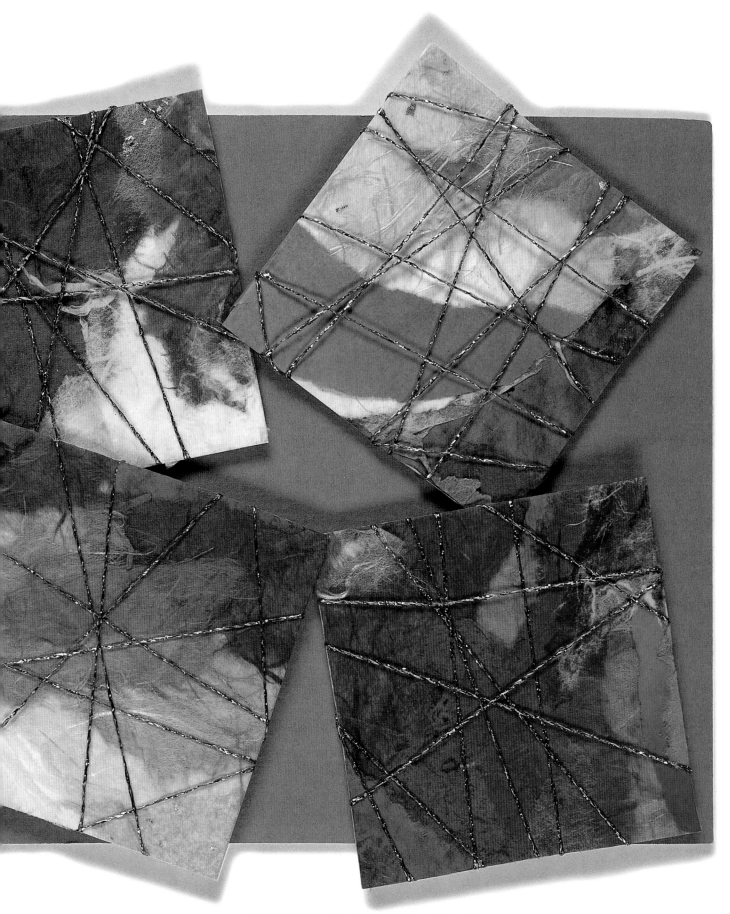

*continued from page 92*

## Here's How

1. **Divide.** Using a ruler and pencil, draw a grid on the back of the collage.

5. **Wrap.** Using metallic threads or wires, wrap each collage section randomly, starting and finishing the thread or wire with tape on the back of the segment. Thread beads on some sections to add interest, if desired.

2. **Cut the abstract collage** into squares of equal size, using sharp scissors or a craft knife.

3. **Arrange.** Turn over all the cutout pieces and arrange them on the backboard, leaving 1/4" to 1/2" between the pieces. Rotate the pieces and shuffle the sections to get a pleasing composition.

4. **Evaluate and paint.** Look at the overall layout and decide what color the backboard should be. Paint the backboard with acrylic or watercolor paints.

6. **Mount.** Attach each collage section to the backboard using foam mounting tape.

## Hints & Tips

- Colored mat board can be used instead of 300 lb. watercolor paper. Suede or velvet papers could be used as a background for a rich effect.

- These collages make fun greeting cards as well as interesting framed pieces.

- Frame in a shadow box frame to accommodate the depth of the piece.

- Make some pieces higher than others by layering the mounting tape.

# New Mexico Memories
## Embellished Collage

*"People call me the painter of dancers, but I really wish to capture movement itself."*

— Edgar Degas

For many years, I lived in southern New Mexico. I love the desert landscape and the area's Native American influences. This collage evokes, for me, the mystery of New Mexico. It's a fun way to incorporate rubber stamping into a collage.

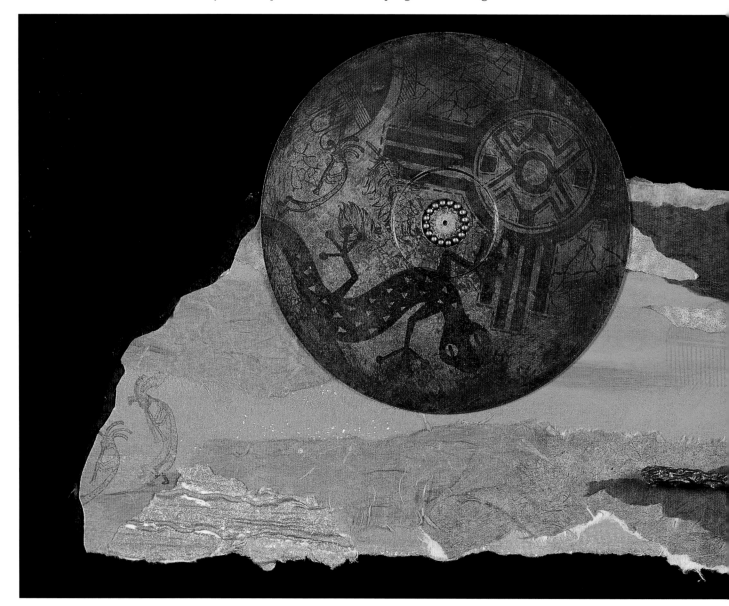

## Supplies

Assorted handpainted and handmade papers
300 lb. watercolor paper, 4.5" x 18", for the backboard
Polyvinyl acetate adhesive
Acrylic matte medium/gel, medium to heavy weight
Acrylic paints, black and metallic colors (copper, bronze, gold)
Dye ink pads, black and brown/sepia
An old computer or music compact disc
Piece of a broken clay pot or terra cotta pottery shard
Gold beads, 4-6mm

Small dry sticks
Rubber stamps with a southwest theme
Spray sealant
1" paint brush, for applying adhesive
Flat artist's brushes, 1/2" and 1", for applying acrylic paints
Sea sponge
Rubber brayer
Scissors

*continued on page 98*

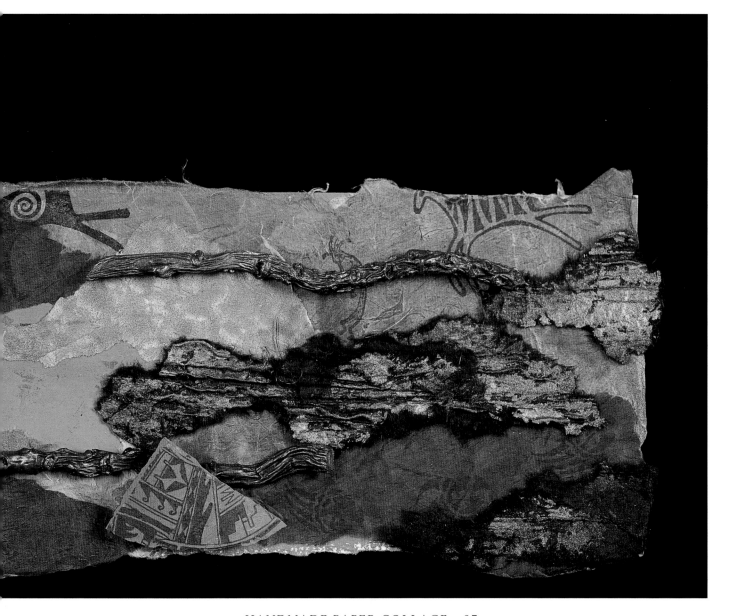

*continued from page 97*

# Here's How

*Get Started:*

1. **Prepare.** Cover your work surface with paper or plastic and assemble your supplies.

2. **Paint the backboard.** Using a 1" flat brush, paint the backboard with an assortment of browns, coppers, and golds. Allow to dry thoroughly.

*Decorate the Compact Disc:*

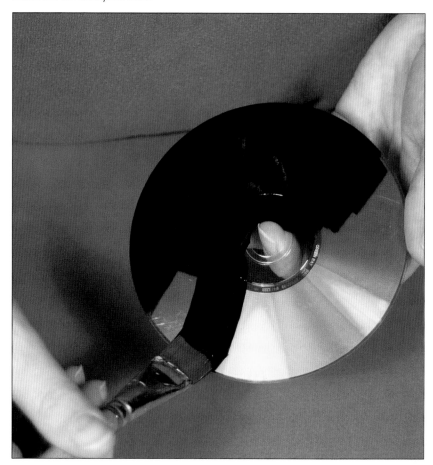

3. **Paint the disc** with black acrylic paint. Let dry. Apply a second coat for solid coverage. Allow to dry thoroughly.

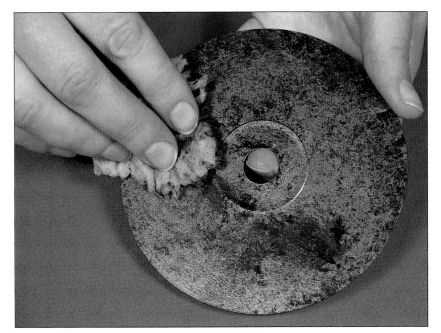

4. **Sponge.** Using a sea sponge, apply metallic acrylic paints to the painted compact disc. Allow some of the black to peek through the colors. Allow to dry completely.

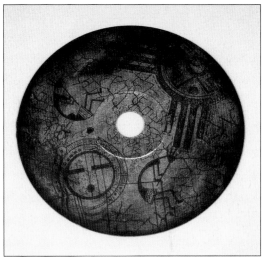

5. **Burnish the edges.** Using a permanent black dye ink pad, rub black ink on the edges of the CD by swiping the ink pad on the CD. Allow to dry.

6. **Stamp.** Using the same black dye ink, randomly stamp southwestern images on the CD. Allow images to extend beyond the edge so some designs are not complete. Don't be afraid to overlap the images, and use an assortment of image sizes. As a final touch, use a crackle stamp to fill the spaces between the images.

*continued on page 100*

*continued from page 99*

*Create the Collage:*

7. **Apply the black paper.** To create an interesting edge on the left of the collage, roughly tear a piece of black paper on the diagonal. Echo the line of the torn edge by lightly tracing it on the backboard. Cut the backboard along the marked line. Glue the black paper to the back of the backboard, allowing the black paper to show 1/4" beyond the cut edge of the backboard.

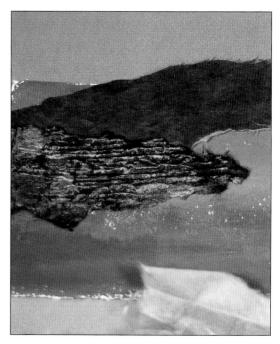

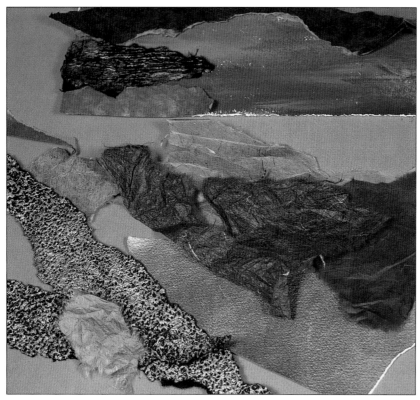

8. **Choose other papers.** Assemble an assortment of papers in browns, blacks and coppers. Using a mixture of textures and colors, tear and lay papers on the backboard. Allow the painted backboard to show between papers as desired, and let the papers extend a bit beyond the straight edges of the backboard. Lay the CD on the collage to help assess the composition.

9. **Glue papers.** When you have a composition you like, glue the papers.

10. **Stamp.** Using stamps with small southwestern images, stamp directly on the collage with black or brown ink, depending on the color of the paper and the desired visibility of the design.

*Prepare Other Embellishments:*

11. **Paint the sticks.** Using metallic acrylic paints, paint the small sticks. Allow to dry completely. Spray the sticks with sealant and allow to dry.

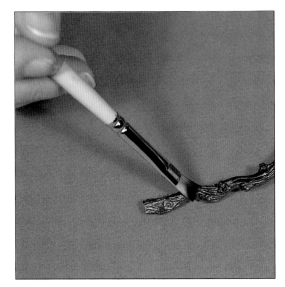

12. **Antique the sticks.** Thin black acrylic paint with water, using a small brush, paint the sticks. While the black paint is wet, wipe excess off with a paper towel, allowing the metallic paint underneath to show.

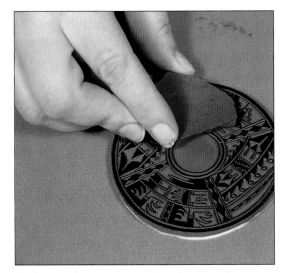

13. **Stamp the pottery shard,** making sure the pottery is clean and dry. Apply black permanent ink to a southwestern-design rubber stamp and lay it flat on the work surface, ink side up. Take the piece of pottery and slowly lay it on the stamp, rocking it gently to cover the curved surface. Allow to dry thoroughly before handling.

*Assemble:*

14. **Glue the CD.** At this point, you have the paper collage glued together and the CD placement determined. Glue the CD to the collage, using acrylic matte medium.

15. **Glue embellishments.** Lay the sticks and pottery shard on the collage to determine their placement. Glue in place, using generous amounts of the thick acrylic matte medium. Leave the collage flat until these heavier items are dry.

16. **Finish.** Glue a flat bead in the center hole of the CD. *Option:* String a few beads together and hang them from one of the sticks.

17. **Mount:** Because you want the rough edges of the piece to show, mount the collage on a piece of mat board. Frame in a shadow box frame that accommodates its depth. ✂

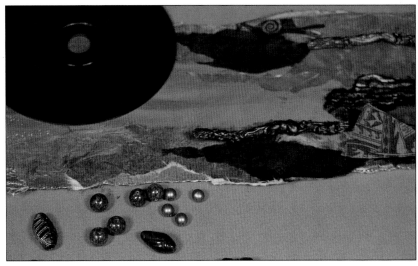

*The mostly complete collage. Beads were chosen to embellish the inner hole of the disc.*

# An Artist's Journal
## Collage Journal Pages

*"I shut my eyes in order to see."*
— Paul Gaugin

Leonardo da Vinci's journal was an impressive array of drawings and notes that reflected his observations of the world around him. To me, this is a fun and exciting way to play with new concepts, record interesting ideas, and create beautiful images with the goal of pleasing only myself.

Sometimes the collages can be done on small pieces of card stock and later glued into a journal, or they can be constructed directly on the paper. Put your thoughts alongside your art as a record of your observations, thoughts, and feelings, letting them reflect today's thoughts or a memory that captures your attention. You will create a wonderful journal to look back on.

Work with found objects, water-slide transfers, and photocopies of photographs, to create wonderful collage journal pages. (I never use original images, but instead scan the images and print to an appropriate size for the collage.) Here, I present techniques I used to create three pages from my personal journal. A decorated journal makes a wonderful, personal gift.

## Supplies

*Read the instructions for more detailed descriptions of the items used.*

Purchased or handmade journal
Handmade paper scraps
Card stock, cream and black
Skeleton pressed leaves, postage stamps, postcards, photographs
Water-slide decal transfer paper
Rubber stamps and dye ink pads
Black permanent fine-line marker
Polyvinyl acetate adhesive
Brush for applying adhesive

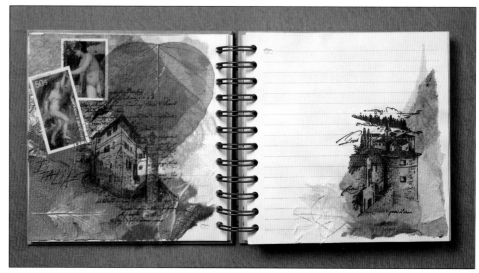

*See larger photo on page 104*

# Here's How

### *Italian Memories Pages:*

1. **Create an abstract image** using handmade and handpainted paper scraps. Keep the pieces glued flat to the paper.

2. **Create transfers.** Stamp and color the images of Italian buildings. Photocopy on water-slide decal transfer paper.

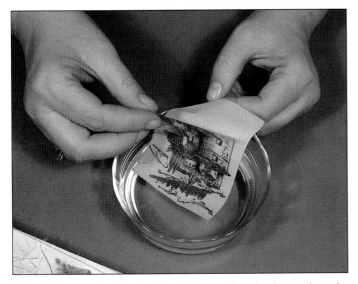

Following the product instructions, soak the image in water.

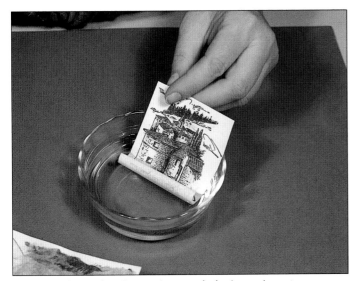

Peel off the paper backing. (This will leave a clear decal to apply to the collage.)

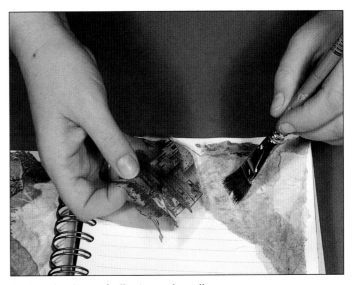

Apply a thin layer of adhesive to the collage.

Place the decal on the page, securing well with adhesive.

3. **Add postage stamps** that show fine art images.

4. **Add skeleton leaf.** Using an actual leaf, apply ink with a brayer and press on cream card stock to create a leaf print. (I used a chrysanthemum leaf from my garden, but any leaf would do.) Cut out and apply to the collage.

5. **Write.** Using a black permanent fine-line marker, write the word "Italia" on the collage.

6. Keep the book open until the adhesive is completely dry.

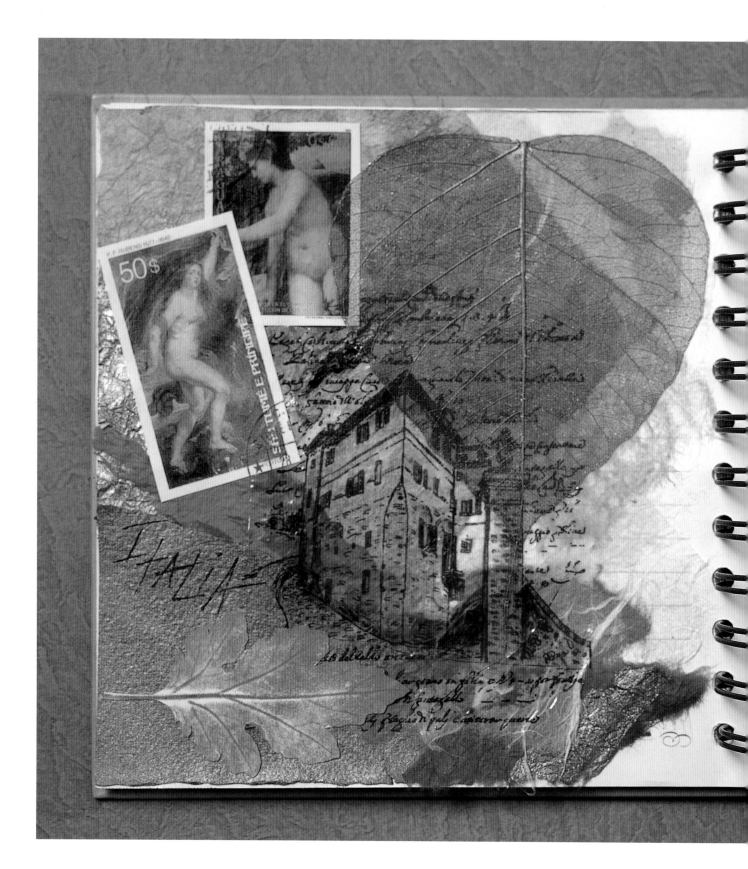

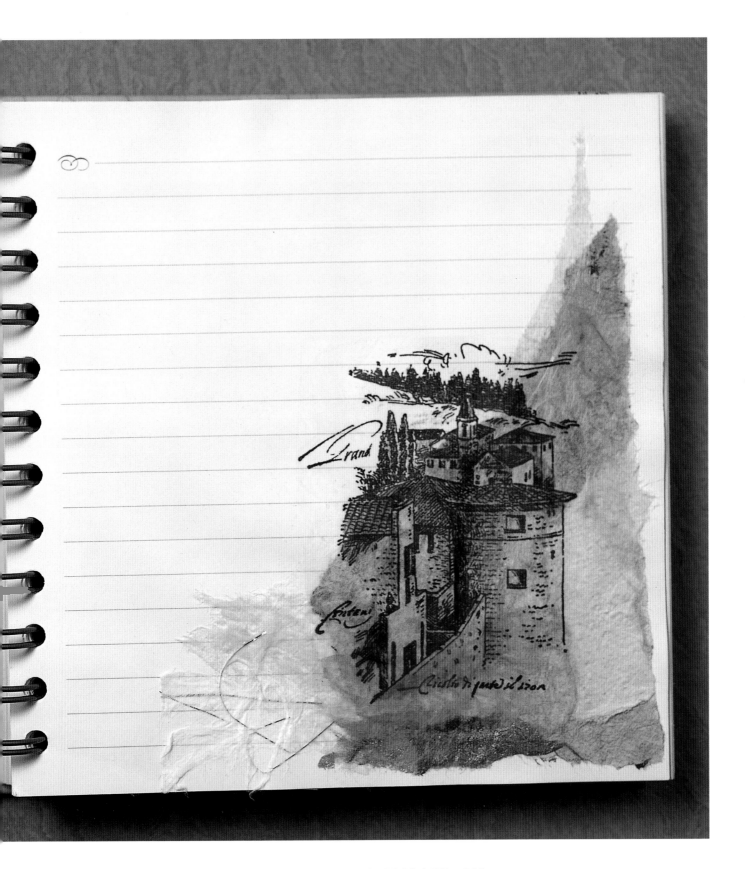

## A Genealogy Page:

1. **Ink.** Use a tan, taupe, and black dye ink pad to rub color directly on the journal page.
2. **Place a reproduction of an old postcard or letter** diagonally across the page. Add scraps of papers around it.
3. **Place photocopies of old family photographs** on the collage. If desired, mount on black card stock.
4. **Glue** the photos to the collage.
5. **Add** a skeleton leaf.
6. **Decorate.** Use water-slide decal paper to add an ornate key and a fleur-de-lis design.

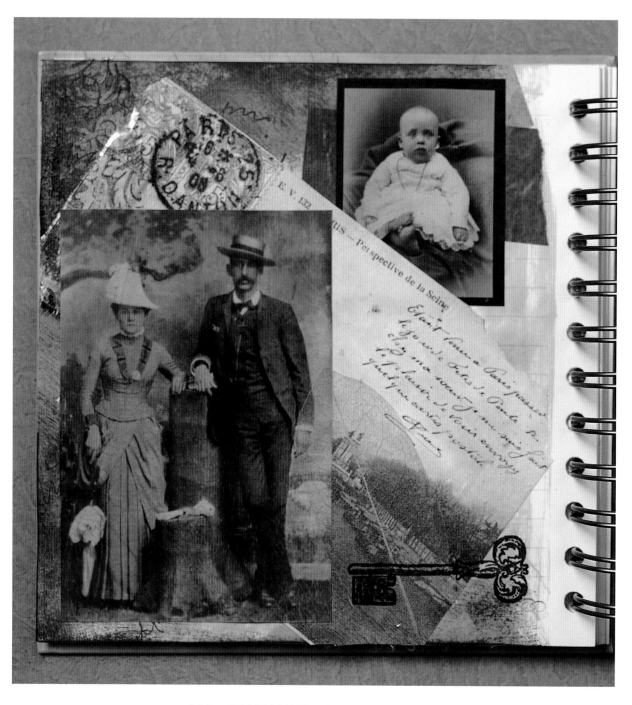

*Pages of Colorful Pears:*

1. **Stamp** (or draw) a pear four times on card stock, using a variety of colors. Cut out the images.

2. **Glue** three pears to the left-hand page of the journal, saving the last pear for the collage on the right-hand page.

3. **Add papers.** Using several scraps of paper, cover the bottom left corner of the page with handmade papers. Integrate a cut-out photo of a flower, if desired, for the top portion of the page.

4. **Embellish.** Place the pear and two interesting postage stamps on the collage. Glue with a light layer of adhesive. Apply

a small piece of lace paper, overlapping the edge of the pear and one of the postage stamps.

5. **Write.** Use the remaining space for writing. I love to collect interesting quotations, so I've written a quote on the page.

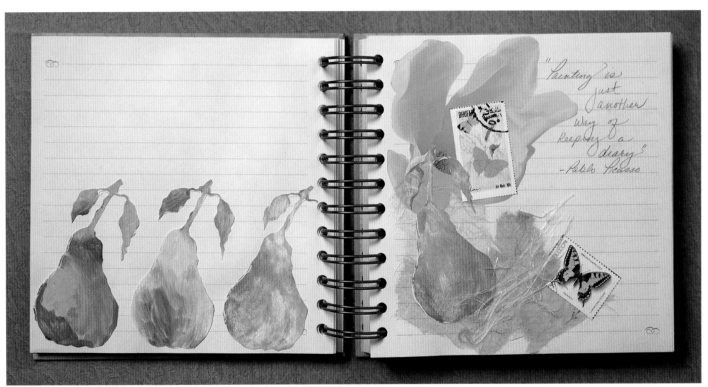

*See larger photo on page 108*

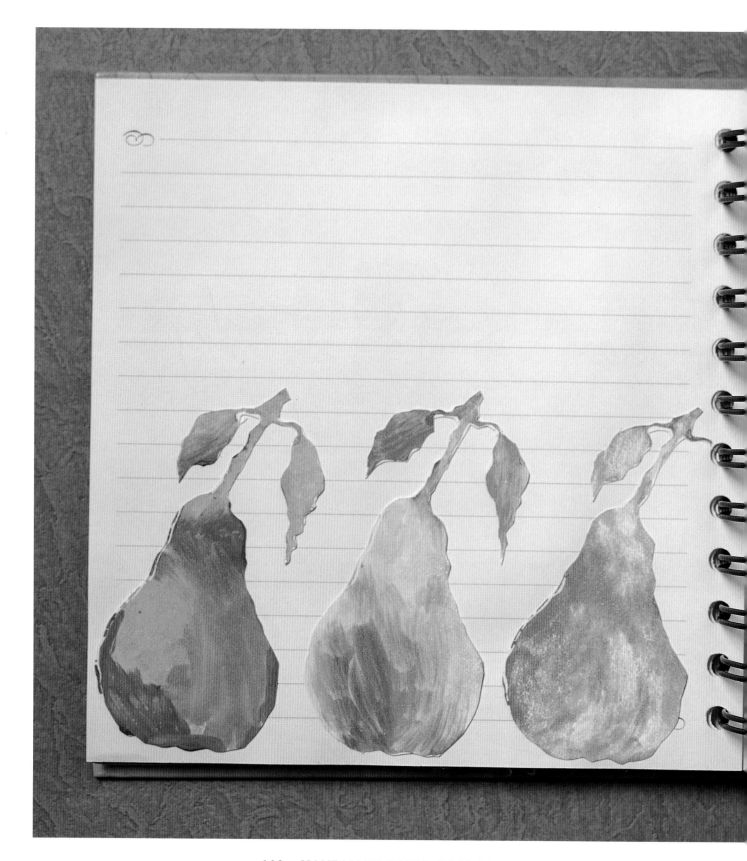

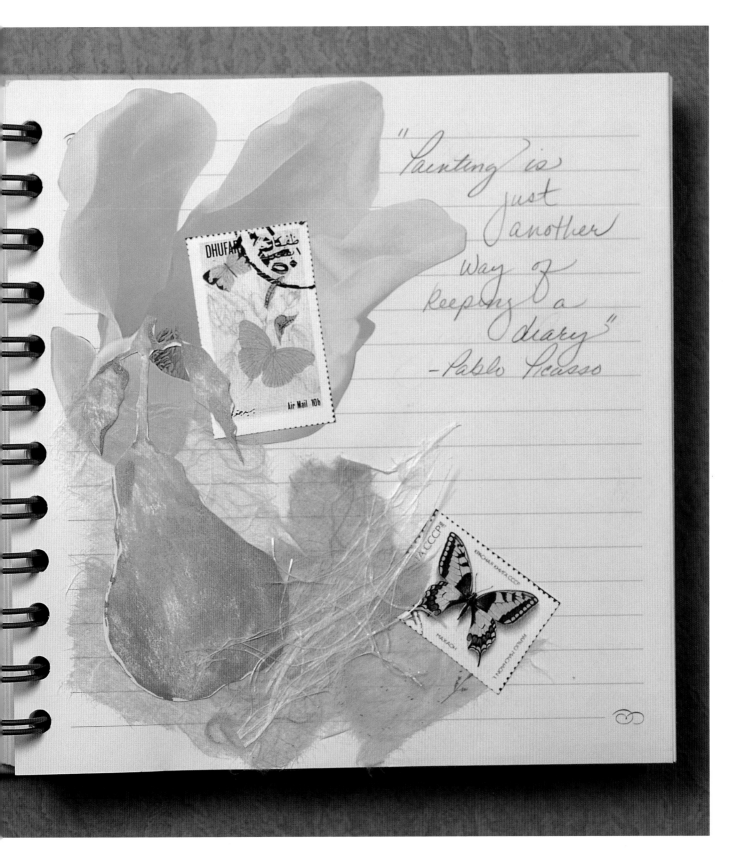

"Painting is just another way of keeping a diary"
—Pablo Picasso

# Collaged Fruit

*"The aim of art is to represent not the outward appearance of things, but their inward significance."*

— Aristotle

People think of collages as flat—something you can frame. But not all collages are flat. These lovely fruit are a wonderful way to use little scraps of papers of all colors. I never feel constrained by the realistic colors of the fruit—I love to see many colors mixed together. Display these fruit for a fun conversation piece.

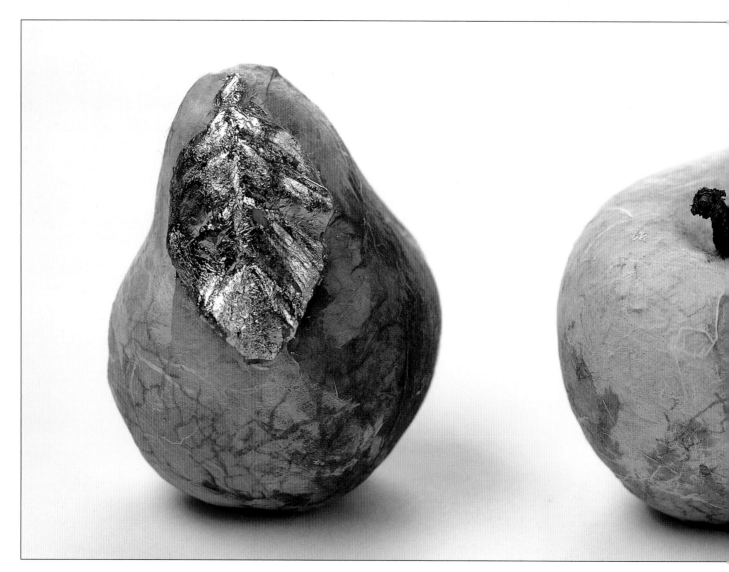

## Supplies

Pear made of resin, hard plastic, or wood
White acrylic paint
Scraps of assorted handpainted and handmade papers
Polyvinyl acetate adhesive
1/2" paint brush, for applying adhesive
*Optional:*
Rubber stamp with crackle pattern

Dye inks in variety of colors
Gold embossing ink
Gold embossing powder
Embossing heat tool
Composite metal leafing material (gold, silver, or copper)
Gold leafing sealer
Acrylic paints, various colors

*continued on page 112*

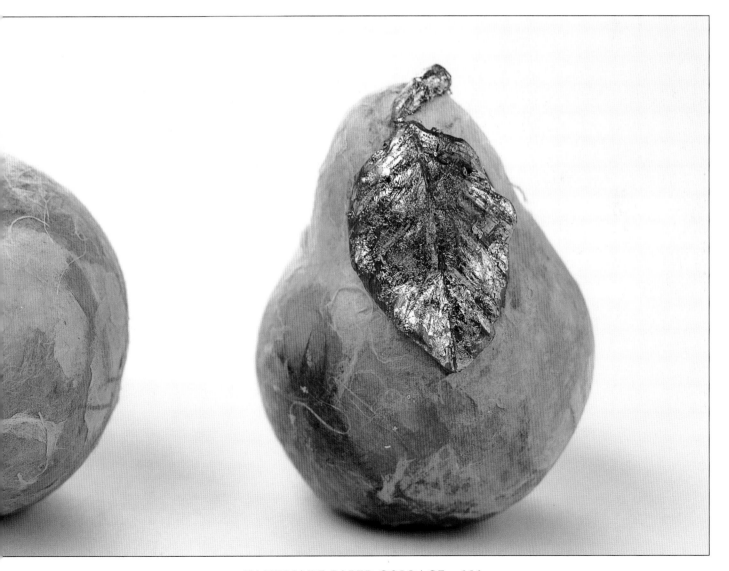

*continued from page 111*

# Here's How

1. **Paint.** Basecoat the pear with white acrylic paint. Allow to dry thoroughly. (This keeps the original color of the pear, if dark, from peeking through sheer papers.)

2. **Apply papers.** Apply papers to the pear one piece at a time.

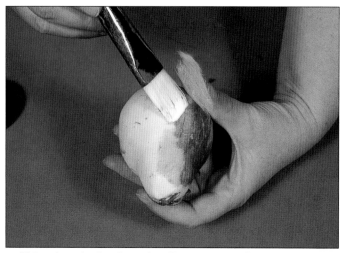

Using the paint brush, apply adhesive to a small area of the pear.

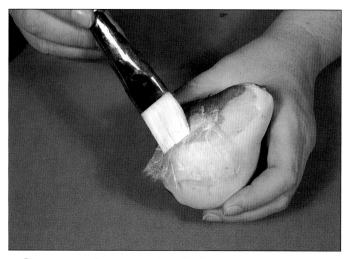

Press a scrap of paper over the adhesive.

Brush the edges of the paper with adhesive to secure them to the pear.

3. **Continue to add more small pieces of paper** to the pear, working outward from the first piece and overlapping the edges until the pear is completely covered. Blend colors to achieve the look you want.

4. **Use sheer and lace papers** to further blend colors on the surface of the pear. Use a heavier hand with the glue to make the sheer papers more translucent and add subtle tints to the underlying color. Brush adhesive over the surface of sheer papers to aid in achieving translucency.

5. **Examine the pear** to be sure that all paper edges are tightly glued to the surface. Use the paint brush and adhesive to secure the edges of the papers, if needed. Allow to dry completely.

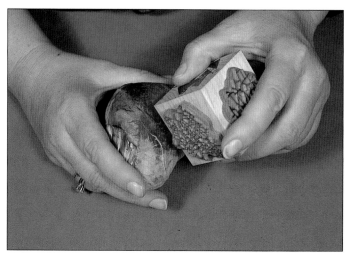

6. *Option:* **Add a crackle stamp.** Using a dye inkpad in colors that complement the pear, stamp a crackle-pattern on the surface. Gently

roll the stamp on the surface to get uneven areas of crackling. You do not want to cover the entire surface—just have small areas of crackling visible. Repeat, if desired, with a second color.

7. *Option:* **Emboss with gold.** Using a gold embossing inkpad, overstamp the pear with the crackle pattern. Emboss with gold embossing powder. Do this one small area at a time. Repeat as desired to achieve interesting highlights.

8. *Option:* **Add leafing.** Cover the surface of the stem, part of the pear, or a leaf with leafing adhesive. Allow to sit until the adhesive becomes tacky, rather than wet.

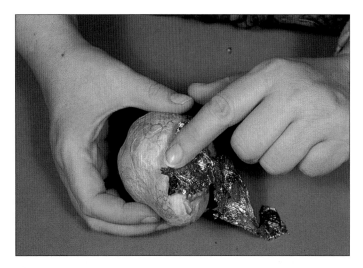

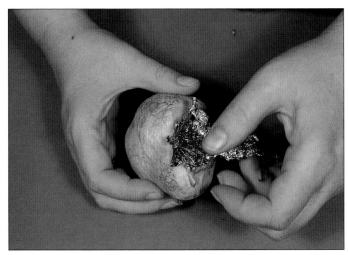

9. Pick up composite leafing pieces and apply to the areas where adhesive was applied.

10. Press in place with your finger. Allow to dry.

11. Using a soft cloth, rub the excess leafing material from the surface. Seal with leafing sealant to prevent discoloration.

## Hints & Tips

- Basecoat the pear with metallic paints in colors that coordinate with the papers to be applied. On areas on the pear that are not completely covered with paper or are covered with very sheer paper, the paint will show.

- Use metallic paint to paint the stem of the pear rather than gold leafing for a more subtle look.

- Look for interesting fruit shapes and make an entire grouping, with a common color theme or a mixture of colors.

For display, they combine beautifully with bead-covered fruit often seen as Christmas decorations.

# Peony

Very rarely do I want to create a collage that looks exactly like something, and this is probably no exception although it may well be the most "realistic" of all my collages. Inspired by close-up photographs of flowers that I have in my landscaping books, I took many liberties and drew this peony. In order to have the collage not be overwhelmed with too many petals, I added shape and removed some petals, creating my own version of this lovely flower. Look to your own garden and gardening books and see what flowers could inspire you!

## Supplies

Assorted handpainted and handmade papers in many
    shades of pinks, peaches, greens, and white (or in
    whatever flower color you choose)
300 pound watercolor paper for backboard, 8" x 11"
Polyvinyl Acetate Adhesive or Acrylic Matte
    Medium/Gel
Various shades of pink watercolor paint
Small round brush
No. 2 pencil
1" Paint brush for applying adhesive
Rubber brayer
Scissors

*continued from page 116*

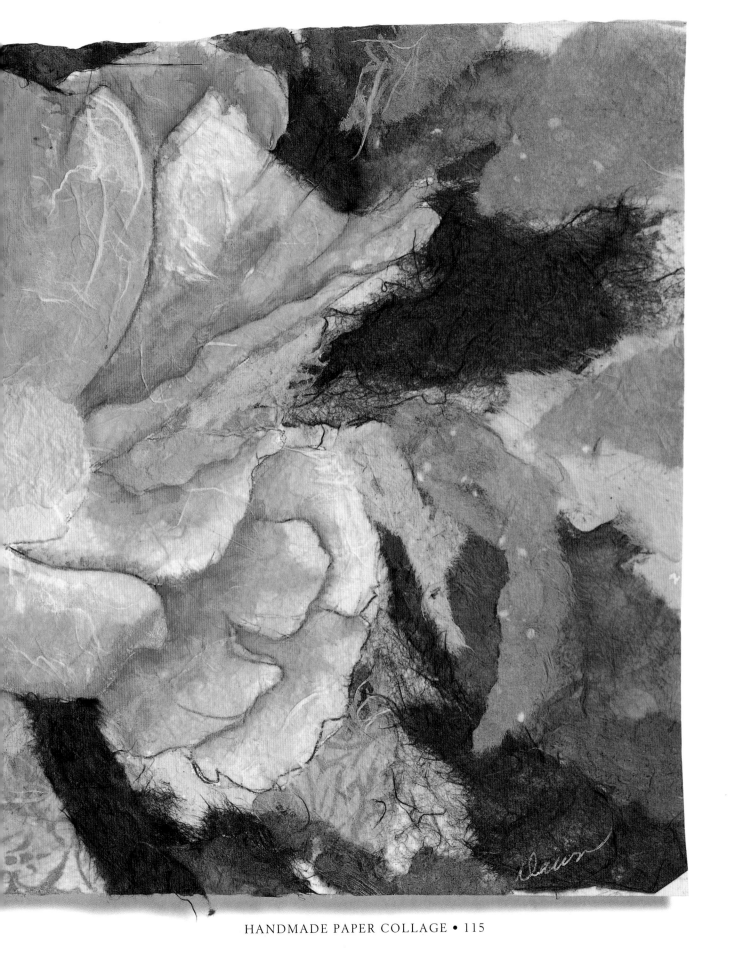

*continued from page 114*

# Here's How

1. Prepare your work surface by covering with paper or plastic and assembling adhesive, adhesive brush, scissors, and backboard

2. Using a pencil, draw the outline of the flower petals onto the backboard. I like to see the lines through the collage papers and so once I have the flower sketched to my satisfaction, I darken the lines of the flower.

3. For this step, create an **underpainting** of the flower to help guide the coloring of the flower petals. *[See Example of this.* This step is optional and you can begin collaging immediately, simply using the drawing to guide you. But I find that just a simple watercolor wash keeps me on track and also gives a little color to peek through some of the sheer papers. You are painting on heavy, 300 pound watercolor paper so you can be very liberal with the water and softly shade the petals with the watercolors. Where the petals are clearly underneath others, shade these a bit darker. Don't worry about creating a beautiful watercolor painting because it will not show later; this is just a guide to help as you collage the papers over the top of the painting.

4. Using various shades of green paper, create a mottled background of green for your flower by tearing and assembling. Notice that I created the illusion of a stem simply by using a strip of dark paper on top of lighter green paper. Come up to the edges of the flower petals, but don't go into the flower itself. This will take some careful tearing of the papers. I found that I was most successful using smaller pieces of paper proximate to the flower.

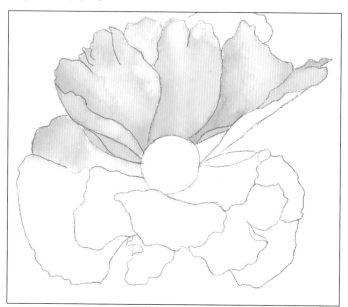

*Creating a base painting for the petals as instructed in step 3.*

5. Begin collaging the flower by gluing on one petal at a time. Tear the papers and glue them flat to the backboard, making sure edges are glued tightly. Overlay dark papers with lighter sheer papers to tone down too dark or too bright colors. Take your time with each petal, shading where appropriate. Do not try to cover all the pencil lines; they will show through and will be needed in the next step. Continue to work all petals on the flower until complete.

6. Allow the collage to dry.

7. If you cannot see the pencil lines, take your pencil and pencil in the separation between petals and any other fold lines you want to see.

8. Using a small round brush and very wet watercolor paints, line the petals along the pencil lines. Do this very carefully, because the handmade papers absorb the water very, very quickly. Not much paint is required and just allow it to soak in along the petal lines. This paint does not cover the pencil lines, but enhances them.

9. Allow the collage to dry.

10. Using shades of yellow, collage the center of the flower. ❧

## Hints and Tips:

- While the flower I created is pink, I used quite a bit of peach along with the bright pinks to create a more interesting coloration in the petals. Also, use white mulberry and lace papers on top of the pinks in order to attain lighter shadings and greater contrast in the petals. The petals probably ended up with 5, 6, 7 layers of papers to get the various shading.

- For the abstract background, I did not have a terrific amount of green papers and yet wanted to see many mulberry fibers. While this is a bit of a strange technique, it worked really well. I applied the light and dark segments of the green papers to the background, then allowed them to dry. Where I wanted to add some dark fibers on top of the lighter papers, I then applied a thin layer of adhesive to the backboard location, and glued the dark paper there. After a few minutes, once it was clearly stuck in place, I peeled the dark paper off the backboard. It left a fine scattering of fibers, which allowed me to blend my colors in a few places where I didn't really have any shade of paper that was working.

- Because you want the papers to fade into one another, rather than seeing distinct pieces of paper, glue these flat, flat, flat! "Paint" the edges of the papers from the top with thinned adhesive to ensure that they are glued down.

*Peony Pattern*
*Enlarge to 116% for actual size*

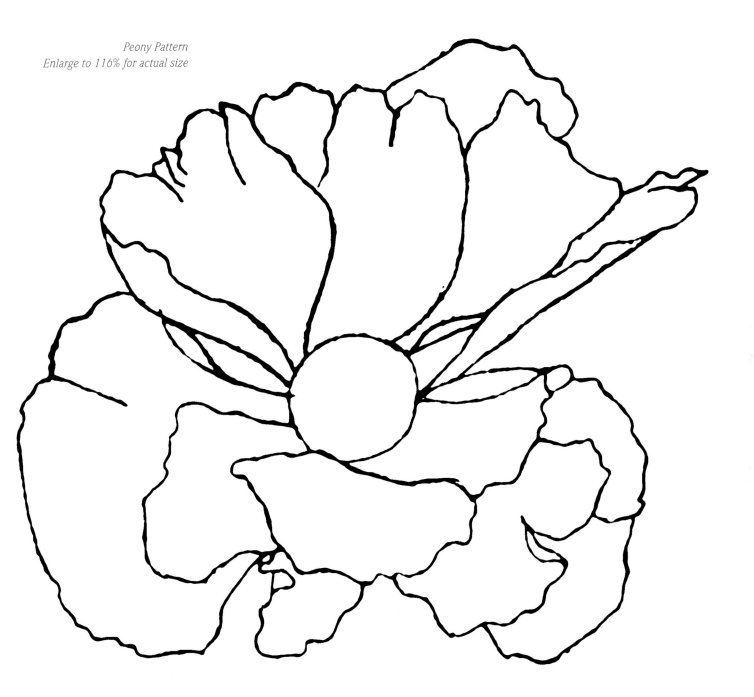

# Tribal Music
## Abstract Collage

*Project pictured on pages 120-121*

This is a fun and interesting collage. I love the line that is created and the depth offered by the embellished surface of the collage. I created this triptych collage and allowed it to sit unfinished for a year because I wasn't quite sure what the next step should be. Finally I decided on the use of painted dowels and wire. The title of this collage comes from the impressions that my family had of the collage while it was in progress. At one point they thought they looked like a tribe of people. Then the dowels started looking like musical instruments as they were being wired together.

## Supplies

Assorted handpainted and handmade papers in two distinct sets of colors, pastels and darks
300 lb. watercolor paper for backboard, 21" x 20"
Polyvinyl Acetate Adhesive or Acrylic Matte Medium/Gel
1" Paint brush for applying adhesive
Rubber brayer
Assortment of dowels, diameters ranging from 1/4" to 1", cut into random lengths between 3" and 10" (you will need about 27-30 pieces)
Metallic acrylic paints in shades of browns/golds/coppers
Copper wire (I used about 30 feet of size 10 wire)
Small drill bit
Pencil
Scissors
Wire cutter

## Here's How

1. Prepare your work surface by covering with paper or plastic and assembling adhesive, adhesive brush, scissors, and backboard.

2. Assemble an assortment of papers for the dark bottom segment of the collage (I used browns, purples, blues) and a separate assortment of light shades for the top. I used dark browns, purples, blues and soft pastel peaches, pinks, lavenders for the top.

3. On the backboard, draw a line which will serve as an approximate divider between the light and dark sections of the collage. Once satisfied, mark the back of the backboard into 3 pieces, each 7" x 20". Cut the backboard into three pieces, marking left, middle, and right. Marking the backboard before cutting the pieces makes it easier to have continuity between the 3 segments of the overall piece.

4. Work the light section of each collage segment first, using narrow strips of papers and extending the light color below the dividing line at irregular intervals. These dips are to accommodate the jagged nature of the division between the light and dark sections. You are looking for a vertical effect to the papers, so the papers are primarily narrow strips running vertically down the backboard. This is less noticeable on the light colors if the shades are close, but will be very noticeable on the darker colors and particularly at the dividing line. The light colors will look like they are almost running down the backboard.

5. Once the light segments are complete, you will again use narrow strips of papers to create a vertical effect in the dark, bottom segment of the overall composition. Bring the colors together in a very jagged fashion at the dividing line, extending the darker colors on top of

the lighter ones, while still loosely following the dividing line you originally drew. Maintaining some integrity to the dividing line will keep continuity between segments of the overall collage.

6. Allow the collage to dry completely.

7. Using the metallic acrylic paints, paint your assortment of dowels in the various shades you have chosen and allow to dry completely. Don't forget to paint the ends of the dowels.

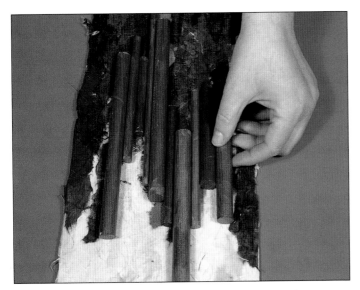

8. Select 9 or 10 dowels in different colors, lengths, and diameters to lay together along the division between lights and darks on one of the segments of your collage. Arrange in an irregular pattern which works with the dividing line and which mimics the jagged nature of the division itself.

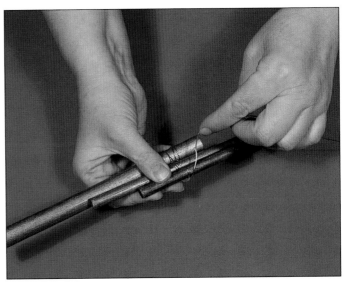

9. Once you have an arrangement of dowels, cut a piece of wire about 3-4 feet long. Beginning with the left dowel, wrap the wire around it, and twist the end of the wire to the long remainder to anchor the wire. Wrap again, then pick up the next dowel and wrap the two together. Each dowel will typically have 2 to 4 wraps of wire around it, and it is important to keep the dowels very close/tight together. Keeping the wire relatively horizontal, continue wiring the dowels together. If one dowel dips too low or too high to continue from the previous dowel while keeping the wire horizontal, just finish off that wire by taking it to the back and twisting it to the wrapped wires and clipping it off. Start a new wire that will create a second horizontal line of wires across the dowels. Continue until all dowels are wired together and stable. You should be able to carefully pick them up and have them stay in place.

*continued on page 122*

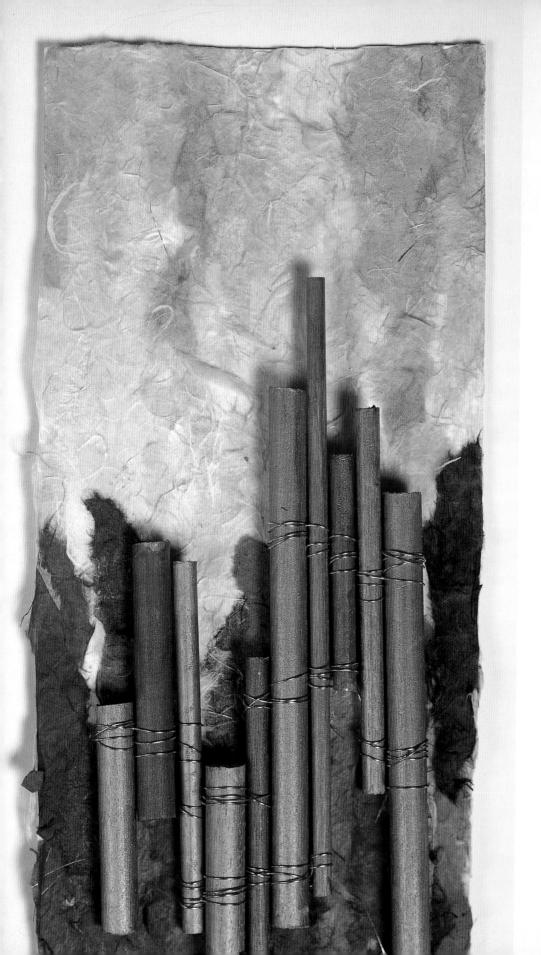

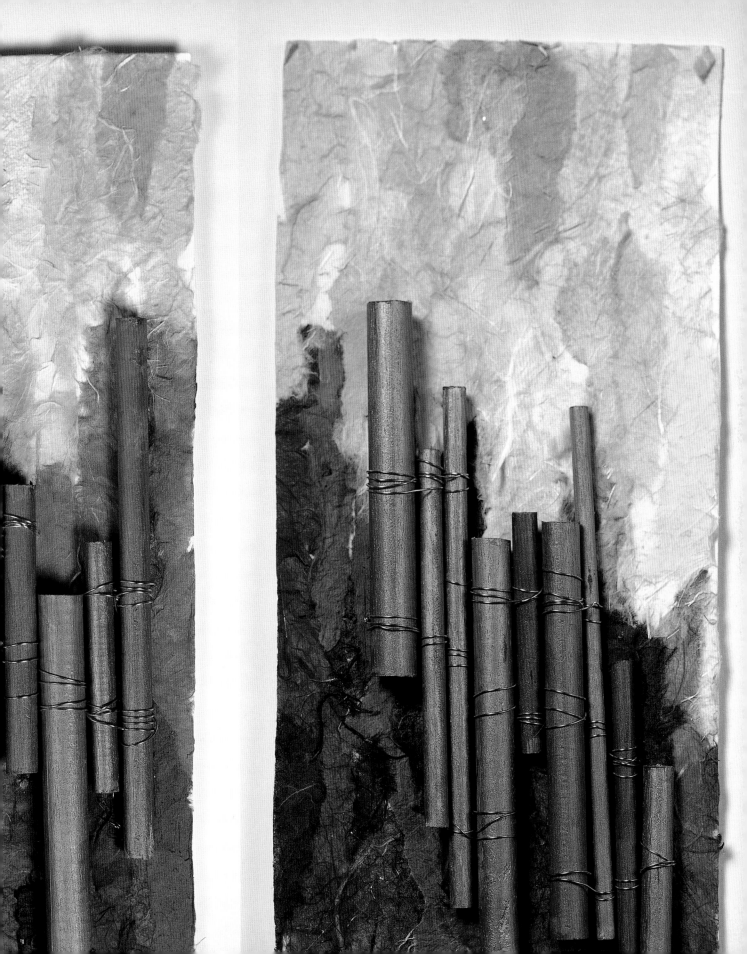

*continued from page 119*

10. Lay the wired dowels into place on each collage segment.

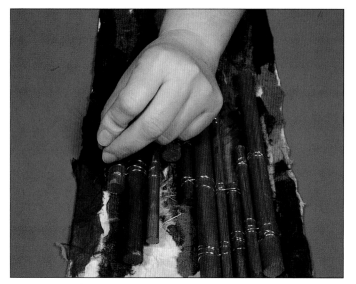

11. The dowels will be mounted to the collage by drilling a hole through the collage and wiring them to the surface. *(Just a hint: if you have ever taken a child's doll out of the packaging with all those twisty-ties, you will recognize this process.)* Twisting the drill bit by hand, drill a hole through the collage.

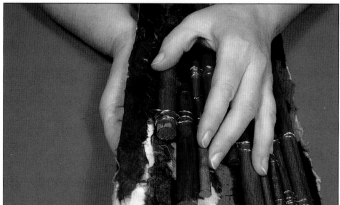

12. Move the dowels and drill a second hole parallel to the first, the width of the dowel.

13. Take a piece of wire, about 4 inches long, and insert each end into each hole, going over the dowel and extending the ends to the back. Twist the ends together tightly to the back of the collage. Repeat this process for 3 points on each segment to securely hold the dowels in place.

14. Mat the collage segments together, leaving between 2 and 3 inches between segments. This will pull each individual segment into a cohesive triptych collage. ❧

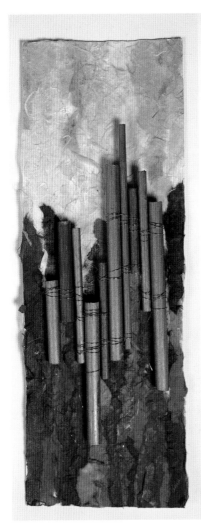 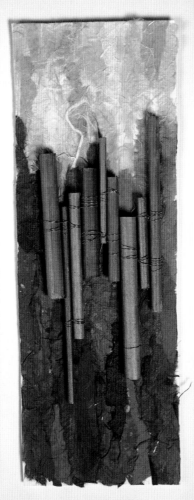 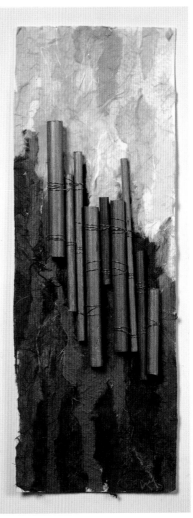

## Hints and Tips:

- As you are collaging, don't worry about keeping exact to the dividing line you drew. It is only there as a guideline; just make sure to keep the line at the edges consistent between segments.

- Experiment with different arrangements with the dowels. I extended some far below or above the dividing line, using the jagged edges as a guide, but not staying true to those edges.

- One other way to maintain some continuity between segments is to carry some of the color from the edge of one segment to the neighboring edge of the next segment. Because the colors I used are quite dark and quite light, the color continuity is not critical, but I still like it.

- Add beads to dangle down from the dowels if desired. I could not quite decide if I wanted to do that so I did not do it for this exercise, but if I keep looking at it long enough, it may end up with beads after all! ❧

# Aspen Trees

When I look out my kitchen window, there is a beautiful stand of aspen trees. The lines of the trees and branches are always beautiful to see, particularly when the sky is giving its most colorful displays. This collage captures the feel of these aspen trees in winter.

## Supplies

Assorted handpainted and handmade papers, including relatively
    smooth, heavy cream and medium brown papers
300 pound watercolor paper for backboard, 14.5" x 17.5"
Polyvinyl Acetate Adhesive or Acrylic Matte Medium/Gel
Dark Brown, rust, black watercolor paint
Small fan brush
Small round brush
1" Paint brush for applying adhesive
Rubber brayer
Scissors

## Here's How

1. Prepare your work surface by covering it with paper or plastic and assembling adhesive, adhesive brush, scissors, and backboard.

2. Assemble an assortment of papers to color the sky as well as the cream and browns for the tree.

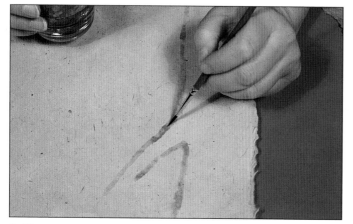

3. Using a round paintbrush, wet the lines of the tree trunks on the cream and brown handmade papers.

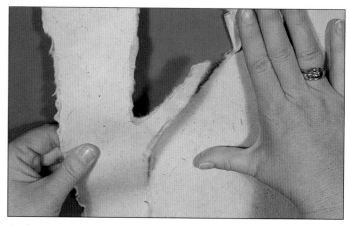

4. Gently tear the papers for four tree trunks: two brown, two cream.

5. Layer the sky papers across the backboard. Note that there is no foreground land in the collage, so the sky will extend from the bottom of the backboard to the top edge of the backboard. This segment of the collage will show between the trees and to the right of the tree trunks.

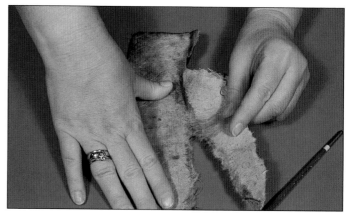

6. Lay the tree trunks from the previous step onto the backboard to get an impression of how the sky will look with the trees in place prior to gluing the sky. Once you are satisfied, remove the trees and glue the sky papers.

*continued on page 126*

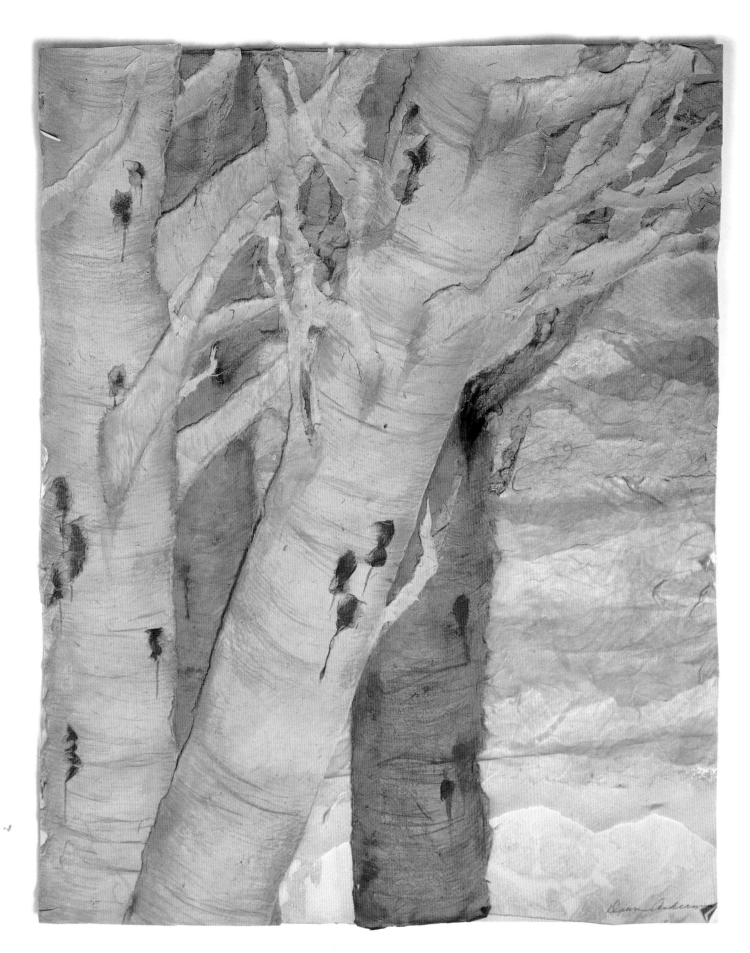

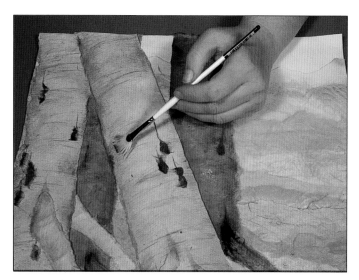

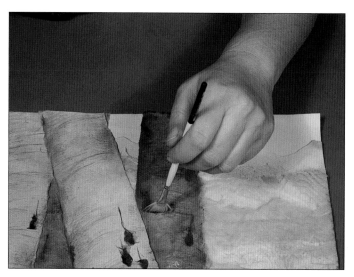

7. Using the fan brush and the dark brown watercolor paint, begin shading the tree trunks with VERY watered down paint. The paper will soak up the paint very, very quickly and will look much darker than when it dries. Begin by shading the edges of the trunk, drawing the brush from the edge of the paper to the center in a curved stroke. This will leave some streaks of color, almost striping, on the paper giving an interesting tree trunk effect. Allow the tree trunks to dry. Once dry, decide if the shading is dark enough or if you need to add more; use your judgement but remember to add light layers of paint because it cannot be lightened once applied to these types of papers.

8. Arrange the tree trunks and glue them to the backboard, on top of the sky papers.

9. Tear large branches and highlight their edges with the same watercolor painting as the tree trunks. Allow to dry completely and then position them onto the collage. Glue in place.

10. Continue to overlap branches and add smaller branches with narrow strips of paper until the tangle of tree branches is to your liking. Glue branches in place.

11. Using small pieces of darker brown papers, place "scars" on the tree trunks, scattered around the branches. Alternatively, use the watercolor paints to paint the scars on the trunks.

12. Allow the collage to dry completely.

13. Using the fan brush, add streaks down the trunk from the "scars" and darken the tree trunk at the joint of major branches.

14. Now is also the time to enhance any other shading or streaking desired on the collage. Use a light application of very watered down paints and allow to dry completely between applications of paint. Remember that the adhesive is water soluble and will allow your papers to come loose if you get the papers too wet.

15. Allow the collage to dry completely. ✌

## Hints and Tips:

- Allow the branches to tangle together for a realistic look.

- When you are getting to the end of the collage, use a wet paintbrush to draw the branch shapes that you want. This gives you control over the line without using scissors, so that you keep those lovely torn edges.

- Be very careful when painting on the handmade papers because they absorb the water, and the watercolor paint, very quickly.

- It is better to shade the papers multiple times, allowing it to dry between applications, than to use too heavy a hand with the paints. My tree trunks probably received 4-5 applications of paint before I liked the amount of shading, but I did have to discard the first one I made when I used too much paint and couldn't blend it well enough on the handmade paper.

# Metric Conversion Chart

## Inches to Millimeters and Centimeters

| Inches | MM | CM |
| --- | --- | --- |
| 1/8 | 3 | .3 |
| 1/4 | 6 | .6 |
| 3/8 | 10 | 1.0 |
| 1/2 | 13 | 1.3 |
| 5/8 | 16 | 1.6 |
| 3/4 | 19 | 1.9 |
| 7/8 | 22 | 2.2 |
| 1 | 25 | 2.5 |
| 1-1/4 | 32 | 3.2 |
| 1-1/2 | 38 | 3.8 |
| 1-3/4 | 44 | 4.4 |
| 2 | 51 | 5.1 |
| 3 | 76 | 7.6 |
| 4 | 102 | 10.2 |
| 5 | 127 | 12.7 |
| 6 | 152 | 15.2 |
| 7 | 178 | 17.8 |
| 8 | 203 | 20.3 |
| 9 | 229 | 22.9 |
| 10 | 254 | 25.4 |
| 11 | 279 | 27.9 |
| 12 | 305 | 30.5 |

## Yards to Meters

| Yards | Meters |
| --- | --- |
| 1/8 | .11 |
| 1/4 | .23 |
| 3/8 | .34 |
| 1/2 | .46 |
| 5/8 | .57 |
| 3/4 | .69 |
| 7/8 | .80 |
| 1 | .91 |
| 2 | 1.83 |
| 3 | 2.74 |
| 4 | 3.66 |
| 5 | 4.57 |
| 6 | 5.49 |
| 7 | 6.40 |
| 8 | 7.32 |
| 9 | 8.23 |
| 10 | 9.14 |

# Index